Patrick Procktor

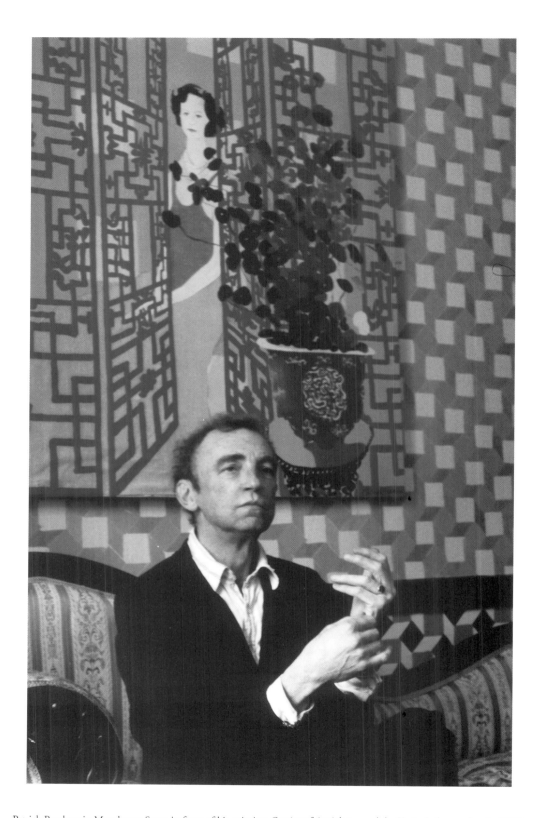

Patrick Procktor in Manchester Street in front of his painting *Coming of Age* (photograph by Karin Székessy taken in 1995)

Patrick Procktor

John McEwen

SCOLAR PRESS

ACKNOWLEDGMENTS
We wish to thank the following for their help in producing this volume:
HRH The Princess Margaret; Roger Bevan; Richard Gault;
Mrs John McEwen; Richard Selby; John Synge; Maggie Thornton

Published on the occasion of the exhibition 'Paintings, Watercolours and Drawings'
at The Redfern Gallery 11 November - 19 December 1997

A limited edition of 75 copies, signed and numbered by the artist,
includes a coloured etching specially created for this volume.

Published by
Scolar Press · Gower House · Croft Road · Aldershot · Hants · GU11 3HR · England
Ashgate Publishing Company · Old Post Road · Brookfield · Vermont · 05036-9704 · USA

First published 1997

British Library Cataloguing in Publication Data
McEwen, John
Patrick Procktor
1. Procktor, Patrick - Criticism and interpretation
2. Painting, English 3. Painting, Modern - 20th century - England
I. Title II. Procktor, Patrick
759.2

Library of Congress Catalog Card Number: 97 - 39673

Hardback ISBN 1 85928 322 5
Limited edition ISBN 1 85928 323 3

Produced for the publishers by John Taylor Book Ventures
Hatfield, Herts
Designed and typeset in Garamond by Lovelock & Co and printed in Great Britain
at the University Press, Cambridge

Contents

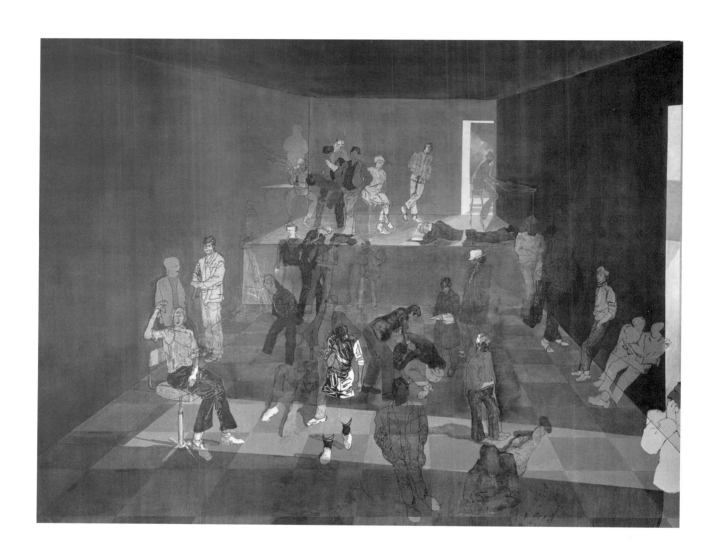

Shades 1966

The Joys of Summer:
The Paintings of Patrick Procktor

'If I summed up his art in a single word it would be charm. Charming in the way Gainsborough is charming and most of the best English art'

<div align="right">Kyffin Williams RA</div>

'I still go into the Redfern when I get a chance, especially to see the watercolours of that graceful and witty painter, Patrick Procktor'

<div align="right">Michael Wishart *High Diver* (Blond & Briggs)</div>

Artists naturally know most about art, and the opinions of the eminent Royal Academician Kyffin Williams, once Procktor's art master at Highgate School, and that erudite painter Michael Wishart must be as weighty as any. Charm might be defined as 'the combination of the grace and wit' which Wishart identifies as the essence of Procktor's art. Both qualities are under-appreciated, certainly under-encouraged, in today's number-crunching world. 'I cannot think why charm has become so denigrated, but it is,' says Kyffin Williams, 'pretension is what gets everyone everywhere today. All that younger artists seem to think about is commercial success.' Williams considers charm the particular virtue and characteristic of English art, the precious result of centuries of peace. 'As a nation we tend not to be desperately churned up. We haven't really suffered and therefore we have the ability to touch lightly on things.'

But of course there is more to Procktor than this. There is philosophical purpose. 'At the Slade you were taught that the important thing was that a conception was your own. The basis of this was truth to perception, depicting the visible in as objective a way as possible. This was a research method and tied in with existentialist philosophy,' he explains. And there is darkness. 'Seven and a half octaves instead of eight,' he says of *Body and Soul* (1981), superficially a picture of an unforbidding piano overhung by flowers, 'and throw in peonies? I call that hard-hearted. You know the song? "Hard-hearted Hannah, the vamp from Savannah, She'd even pour water on a drowning man".'

Quotations, when unfootnoted, derive from conversations with the author.

Gervase 1968

The English artist also has to contend with the rooted disapproval of puritanism. Procktor is a purist rather than a puritan, appropriately born in Dublin. Though not Irish, he has a fondness which lingers in his loyalty to Sweet Afton Irish cigarettes. And he has a Wilde side: 'On the carpet at Ann Fleming's, Francis Bacon and Lucian Freud asked which painters I admired, so to study the expression on their faces I said "Francis Rose and Stephen Tennant"!'

Stephen Tennant, dilettante painter, poet and writer, inspiration of Beaton and friend of Rex Whistler, the Mitfords and the Sitwells, was a key component in that vivid artistic strain, of which Procktor is a part, at odds with the dullness of the English utilitarian spirit. One must live, Tennant always said, 'at the heartbreak of things'. Procktor describes him as an 'English Bird of Paradise and source of merriment' whose pictures he hangs and letters he keeps. The description could easily fit Procktor himself. His striking and stylish presence is matched by an œuvre devoted to the *douceur de la vie*, to beauty in all its forms, a recipe for melancholy. Can that 'sweetness of life' ever escape the timeless bounds of youth? Nothing captures it more eloquently than the young people in his pictures glimpsed posing, reading and dreaming the hours away: from *Leather Boy in a Field* (1963), to *Gervase* (1968), *Peter in Luxor* (1984), *Juliet* (1982). There are few old people in his art, few winter scenes. There are also markedly few English ones.

Procktor has always been attracted by ancient and exotic places – China, Egypt, India, Japan, Morocco, Venice – often travelling by boat in the old romantic way. But he always comes back, despite his hatred of the London mess, conservative politics, the weather. He attributes it to his *nostalgie de la boue*. David Hockney, his early friend and travelling companion, says he thinks of him going farther and farther East as the years go by, presumably in the growing simplicity of his art as well as geographically. (Hockney went West, hence Procktor's nickname for him 'Mae West'.) Procktor finds life afloat, the special sense of time a traveller has on a voyage, conducive to painting. Stephen Tennant's description of Cecil Beaton's *Time Exposure* could well apply to his art:

> '… this book, this bouquet, a *corbeille de fleurs* real and false, evokes the *carnet de bal*,
> in pink cardboard, stamped in silver, new; newer than the freshest invitation;
> accompanied by a posy of moss-roses and blue forget-me-nots, corseted and framed in
> tulle and ribbon… in Cecil's art it is always the birthday morning, the eve of the ball,
> the rise of the curtain.'

'I was not an art-gifted child,' Procktor insists in *My Britain*, a TV memoir made for Channel 4 in 1988. Painting played little part in his upbringing, the formative years of which were spent in his grandparents' house on Marylebone High Street. But his mother, and especially his grandmother, a talented amateur painter who initiated his passion for bridge, had a taste for art, so long as it was not 'modern'. 'To them Picasso, for example, was a very smart operator who for years and years had got away with fooling the public,' he told Noël Barber in *Conversations with Painters* (Collins, 1964). 'It never entered their heads that perhaps all these years Picasso had been producing work which expressed something not only important, but true.'

Procktor's first artistic love was the theatre. His Scottish cousin Andrew Faulds, much his age, went on to become an actor. Acting is in his blood. School plays were an important feature of his life at Highgate, where in the junior school he played Lord Derwentwater in a suit of imitation armour made by sewing silver milk-bottle tops to a pullover. In the senior school he was the lawyer in Shaw's *The Devil's Disciple* and hammed as much attention as possible out of the Scottish Doctor in *Macbeth*. There were school excursions to professional productions. He was impressed by Barbara Hepworth's sets for *Electra* (1952) at the Old Vic – particularly by the enormous scale of the columns and the daring simplicity of the whole effect.

In capital letters on a page of his notebook many years later, 29 September 1991, he wrote:

'THE ARTIST IS AT THE CENTRE OF LIFE'S MAGIC'.

This is certainly true of his own life, which centres on a corner of Marylebone where he has lived in the same house for 30 years. In the hall is a rare hand-coloured lithograph of theatrical costumes by Picasso, a present from Procktor's friend, the writer, exhibition organiser, balletomane and pall-bearer at Nijinsky's funeral, Richard Buckle; in the dining-room there is a landscape painting by Arthur Dundas of the Murray River Valley in Australia, when it was still virgin land: 'Which I love,' he says, 'And do you know what that white dot is? The tent he stayed in when he painted the picture. My friend Kenyon says it's a sheep without the legs! But it isn't. It's his tent. Isn't it a beautifully painted picture?' On the other walls are some of his own works: the large flamboyant 'fantasy', *6AM at Heaton Hall* (1966); and by the door the modest *Peter in Luxor* (1984), an oil-on-canvas souvenir of his first evening in Luxor, its urgent brushstrokes indicating it was done on the spot. 'As Whistler said, "Started one day, finished the next". "And for that you ask 200 guineas?" said the judge in the Ruskin/Whistler lawsuit. And what was Whistler's answer? "No, I ask it for the knowledge of a lifetime." The light in Egypt is violet,' he says, 'in China daffodil, in Venice opalescent.'

A bottle of wine sits on the table in the dining-room, an Indian takeaway is warming on the hot plate. Meals, like drinks and friends, materialise without any apparent effort on his part. His art has the same quality. 'Watercolour either works or it does not. If it doesn't you just rip it up and start again.' Kenyon duly appears, dropping by after a hard morning's work as a salesman in a shopping emporium, so do others: Nicky, his son, Kestrel Boyle the sculptor, Jill, Michael. Procktor knows everyone, as you learn if you take a stroll in his company. 'Hello Patrick!' says a glamorous young mother with a baby; 'Hello Patrick!' says the Pakistani greengrocer, interrupting a sale to shake his hand.

Nearby is the Roman Catholic church of St James's, Spanish Place, which Procktor tried to join in order to be married in the same place where the body of Nijinsky once lay in state. And round the corner is the Wallace Collection, with its peerless collection of Bonington watercolours and Procktor's 'most beautiful neighbour' Perdita, Mrs Robinson, the actress, painted by the three great English portraitists of her eighteenth-century time: Gainsborough, Reynolds and Romney. Reynolds wins, in Procktor's opinion, because his treatment is the most realistic.

In *My Britain* Jill Bennett says of Procktor's portraiture that he has a 'way of invading one's thoughts without being embarrassing about it'. And in answer to whether he thought himself more of a portraitist than a landscape artist: 'I don't really make a distinction – eyebrows are rather hedgelike on the whole'. In his topographical work, light and reflection take priority, with architecture third.

At school he shone at Classics, and the influence remains: 'The perfect life painted for us by the Greek and Roman poets, the perpetual sun, the life of the forum, the toga, the athlete and philosopher in one body, it all sounds exceedingly delightful when you're sitting in a stone classroom. The other night I had the privilege of sitting down to dinner in the temple of Xanthos in the British Museum, under perpetual spotlights rather than perpetual sun. A long way from the idyll of Mediterranean life I absorbed in childhood, but still one that pleased me enormously. It comes out in my own way in the paintings, in the paintings from the trip to Greece with Michael Upton that made up the first exhibition, and I hope in others.'

It does – the delight always tempered in his mind by that serpent in the garden, the impossibility of perfection. 'The torture which the artist knows better than any is the love of KALOS set against the KAKOS of what he can do.' When I congratulate him on *Corporal R J Ransome, 1 Royal Anglian* (1983), one of the series on British troops in Belize commissioned by the Imperial War Museum, he looks pained. 'Thank you, that's very kind; but in person he was so much more.'

Procktor's classical education makes him exceptional, now that Classics is barely taught. Through it he knows European melancholy at its source; and this was compounded later by his bilingual ability to read Russian, most melancholy of literatures. 'Is there anything Chekhovian about it?' I asked facetiously about *Rose* (1991). 'The dark,' he answered, without a trace of irony.

It was in melancholy post-war Brighton, where his mother was manager of the Grand Hotel, that he decided to be an artist. There may have been an element of defeat in the decision. The critic Andrew Forge once described Procktor in a review as 'a comic off the old boards', a description the artist still approves. 'One hopes to entertain,' he says. He has the elegance and flamboyance of an actor and treats the world as a stage where everyone is his 'darling'.

'In my own case I would add a fourth element: *le temps perdu*,' Cyril Connolly wrote as an old man in a review of *Greek Pastoral Poetry* (Penguin Books, 1973) in *The Sunday Times*: 'for Theocritus was one of the set books in my school curriculum, grafted on to the motes dancing in the classroom, the elms and towpaths and cries of coxes of those summers long ago.'
He quoted from Moschus' immortal 'Lament for Bion':

> Ah, when the mallows perish in the orchard,
> Or the green parsley, or the thickly-blossoming dill,
> They grow again, and live another year;
> But we who are so great and strong, we men
> Who are so wise, as soon as we are dead,
> At once we sleep, in a hole beneath the earth,
> A sleep so deep, so long, with no end,
> No reawakening. And so it is for you.

'I sometimes wonder,' Connolly continued, 'if it is good for boys of sixteen to be made acquainted with the cream of ancient literature – Virgil, Horace, Homer, Theocritus – when they are so remote from the background. Should not the maturity of genius be reserved for the intellectually mature? But then we lose the juxtaposition when "the boys of summer" are confronted by these masterpieces, which will adhere permanently to their memory screens among the loss and litter of awakening sexuality.'

When Connolly retired from *The Sunday Times*, his colleagues, at the instigation of the art critic John Russell, offered him the choice of a leaving present, either a bundle of letters by Byron or a painting by Procktor. Connolly chose the second, coming to the studio and selecting the 1977 oil *Scalorini del Bovolo, Venice*.

A picture of the Parthenon, derived from a black and white photograph, set in a Welsh landscape under a tempestuous Welsh sky, was one of Procktor's first boyhood successes. The chosen subject was in order to please Kyffin Williams, renowned for his Welsh landscapes. It was Williams' example which persuaded Procktor that to be an artist could be a 'proper job'. Williams showed him his studio, where he pulled out a heap of watercolours and invited him to choose one. Procktor plumped for a summer scene. He was also invited to Williams' exhibition at the Leicester Galleries, the first time he stepped inside a West End gallery. 'I don't think I taught him anything,' Williams insists, 'he was naturally able. He just drifted into my art class, knocked off some very pleasant watercolours and oils, and drifted out again.' Williams has lived to see his former pupil join him as a Royal Academician in 1996, something he says would and should have happened years ago but for bad luck.

Procktor was clearly destined for an Oxford scholarship but the money ran out and he was forced to leave school at sixteen. Two years followed working for a firm of builders' merchants, which he found 'repellent' in its petty restrictions, before National Service in the Navy came to his rescue. He enlisted as a student of Russian, which required attendance at the School of Slavonic Languages at London University and the Joint Services School for Linguists at Crail in Scotland. There he played the part of Khlestakov in Gogol's *The Inspector General*, a production favourably reviewed by Kenneth Tynan. But despite this theatrical success he dismissed acting as a possibility because of his exceptional height, now six feet six. So tall and slender is he that Ann Goring remembered in later years being frozen with apprehension at the sight of him in a *motoscafo* in Venice, swaying alarmingly over the rail at every corner like a tapering tree in a gale.

He enjoyed his time in the Navy so much he entertained dreams of re-enlisting. 'I came closest to this when leaving the Slade, prospectless and penniless; the giddy allure of returning to the Navy with a commission involving work for two days or so a week, the rest of the time being devoted to rendering in watercolour one's chosen subject of the sea, ships and men, with ultimately perhaps a one-man exhibition at the Leicester Galleries by Lt Cmdr Procktor RNVR, was very strong, but all came to nought.'

While Procktor was stationed in Scotland in 1954 Richard Buckle staged his Diaghilev exhibition, which Procktor saw when he visited London. He was eighteen years old. 'As Alice B. Toklas wrote about Paris in her youth: "Everyone was eighteen, one or two people were twenty-six, but they did not count". Exhibitions are always the greatest when you are eighteen, and the two that year were Francis Bacon at the Hanover Gallery and Richard Buckle's "Diaghilev".' He became friends with Buckle, who a decade later secured him the major commission of designing some vast murals for the Pavilion of Emergent Nations at Expo 67 in Montreal. *Expo 67 Montreal Mural Design* includes a placard of Mao, a ballet dancer, the Rolling Stones and other totemic figures of that restless time.

Nineteen fifty-eight marks the start of Procktor's career as an artist. He exhibited at the celebrated Redfern Gallery summer show, where he sold a painting of an Icelandic poppy, the sort of frail flower

– *Campanula* (1988) or *Poppy* (1991) are other examples – , doubled by its reflection he has made so much part of his subject matter that one now thinks of it as 'Procktorish'. How does one paint a fast-fading flower? 'As fast as you can! You've only got that one hour. It was the same with *Lotus Scented Cone Incense* (1969). I had to paint it before the incense burned up. That's part of the attraction of watercolour. It always has that edge of urgency because it dries so quickly. It's a gamble, a throw of the card.'

In 1958 he was also accepted as a student at the Slade. The painter Roger Cook, today Lecturer in Fine Art at Reading University, joined the same year but had known him somewhat longer. He was younger, having missed National Service, and deeply impressed. 'Then as now, Patrick seemed immensely sophisticated and brilliant. He was very influenced by the paintings of Bernard Buffet when he arrived, and I too thought they were marvellous, but he soon dropped him for Bomberg. He did some impressive paintings of elderly people at that period. He was much more confident than I was and soon got in with the right crowd – Mario Dubsky, Dennis Creffield and other Bombergians. The Marxist John Berger, who was the fashionable critic of the time, lectured at the Slade, and Patrick, who I think was still a card-carrying communist, became friendly with him.' As head of the student sketch club (always a position held by the school's livewire), Procktor invited Berger to give a 'crit' and award the prize. 'To my dismay he didn't choose me, he chose Mario!' Instead Berger invited him to play ping-pong with him and his girlfriend at his house in Hampstead, not an adequate substitute!

'The Slade is one of *the* civilised places in the world,' Procktor declared in *My Britain*. He loved his time there. Every Christmas and on his birthday Aunt Kathleen sent him a tube of titanium white oil paint, which she continued to do for many years, until her death. Sometimes his jeans were so thickly coated with paint they could stand up on their own. He was a brilliant student, winning the Murray Landscape scholarship from the Royal Academy two years running; first prize at the Slade for the Wilson Steer Competition for still life and landscape; at the end of the course he received an Abbey Minor Travelling Scholarship and went to Italy and Greece.

He made the most of, in his reckoning, an extremely good staff of teachers, among them Robert Medley, Peter Snow and Nicholas Giorgiadis in the theatre design school. His favourite teacher was Claude Rogers. 'Look at what is above what, and what is opposite what,' Rogers would advise; but his influence was surely more subtle. Rogers always had an eye for the overlooked obvious – the view from an aeroplane, hospital nursing and agricultural straw burning were just three subjects he concentrated on during this time and Procktor has inherited this eye for the inconsequential, winkling novelty from familiarity: not the view through the window but the window itself in *Cataract Terrace, Aswan* (1984). It is typical that he thinks 'Michael Andrews' best picture is the one of a balloon where you don't see the balloon at all but only its shadow'.

His student friendships, especially those with the Bombergian circle of Dubsky and Creffield, proved equally influential. Procktor had done plenty of drawing and talking but had not yet found his own way in painting. The Bomberg example was compelling. As Upton says: 'Bomberg looked gutsy, tough, uncompromising'. The only acceptable media were charcoal for drawing and very thick, dark, oil paint for figurative painting. ('It's been as dark as the Slade,' Procktor once said to me of a sunless winter day.)

A comment by the Slade lecturer Andrew Forge, (a farmer's son using a farming metaphor), made him realise a picture did not need to be so 'thoroughly dug over' as he then thought. He was attracted

to the possibility of colour intoxication and incoherence, a more daring approach. Nevertheless 'there is a note of the Slade tradition of drawing and unexpressionist restraint in colour that comes across boldly in the best pictures' (G S Whittet, *Dictionary of Contemporary Artists,* (St James's/ St Martin's, 1977).

Another Slade bonus for Procktor was William Coldstream, the charming and tolerant Principal. 'Coldstream personified the qualities of the heroes in painting he loved: Poussin, Ingres, Corot, Cézanne, the beauty of draughtsmanship. He created, as Ingres did, a circle of artists, contemporary and younger, for whom aesthetic response to reality was given its classical form. We were touched by his power to give warmth to the empty fireplace behind the nude. Fire.' Procktor had a lasting friendship with Coldstream. 'I remember his concern for Bill Coldstream,' writes Peter Snow, 'when he was having a nervous breakdown, when others were not so concerned.'

It is sad that beyond the Slade Coldstream is remembered less kindly as the chairman of the Coldstream Report on the reform of art education. 'The Report was a disaster,' claims Kyffin Williams, 'it destroyed discipline, destroyed the idea of painting what you love. It gave rise to junk art, something that could be copied by any member of the public. Patrick

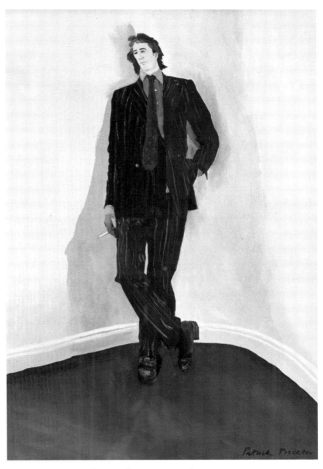

The Columnist 1974

has floated through, unaffected. His art seems to come easily from an easy mind. He does paint what he loves.' Procktor too disapproves of the Report: 'It made students have to have A-levels to get into art school, which is irrelevant'.

Etching was the first new medium to excite Procktor when at the Slade, because it is particularly one of discovery. He experimented freely, even to the radical extent of doing illustration. To be illustrative was generally thought a cardinal artistic sin among progressives, as it still is. This abhorrence has a long history. 'The mission of art is not to copy nature but to express it! You're a poet, not some paltry copyist!' exclaims the old painter in Balzac's story of 'The Unknown Masterpiece'.

By the 1950s the vogue for abstract art, which Procktor resisted, considering it basically nihilistic, meant that any form of figuration was damned as illustrative. This prejudice did not infect the Slade where he was lucky in his etching teachers; the veteran Anthony Gross, born 1905, a meticulous craftsman of the old school; and Procktor's near-contemporary Richard Beer, who emphasised the enjoyment of the art. Beer 'had a terrific sense of pleasure in finding what the medium can and cannot do' and delighted to demonstrate how a 'mistake' in the application of the acid could be turned to advantage: 'I accidentally inhaled nitric and slept for six days!' But when one sees an early Gross sketch for Cocteau's *Les Enfants Terribles* it is easy to believe that the older artist had a stylistic as well as a technical influence.

Aquatint and watercolour came much later. Only maiden aunts did watercolours, a fact Richard Buckle still teases him about by sending Christmas cards in the form of reproductions of the watercolours of the Victorian Dolly Sandford, Buckle's Great Aunt.

'I painted in watercolour as a child but it was considered far too lightweight as a medium when I was an art student,' he told his friend David Gwinnutt in an interview for *Ritz* in 1985. Nevertheless Michael Upton, whom he met during his art school days, remembers long discussions with him about watercolour; Upton, who was at the more traditional Royal Academy Schools, was a watercolourist and not a printmaker.

In Procktor's professional chronology, printmaking preceded watercolour; his first lithograph as a professional artist was produced in 1965, when David Hockney persuaded him to make a print at the Gemini Studio in Los Angeles.

Printmaking in the mid 1960s enjoyed a revival comparable with the etching fever of the 1920s from which the joke 'Won't you come up and see my etchings?' still survives. Prints suit the pockets and aspirations of art collectors in economic booms. In the penny-pinching and conservative 1990s printmaking is once again at a low ebb. As for watercolour, always the poor sister of oil painting in the West, it has passed out of the art syllabus as taught.

A Procktor note reads: 'In all the years at art school no watercolour box was ever seen. Handmade paper was used for etching. Art Brut reigned, a world away from the consumptive Richard Parkes Bonington taking his covered chaise all morning on the Quai, drawing sunlight and colour into the darkness of the cab. English watercolour is the one medium suited to winning, and has that human

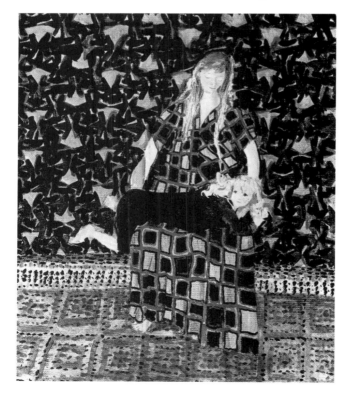

Woman and Child 1977

appeal like racing, like Prince Monolulu "I gotta horse", that visual curiosity straightened by essential companionship with the medium, Madame Askathy herself conjuring one sable to the colour. In this Bonington won but, noble Olympian as he is, Ruskin lost. How one would have loved to have known them. By winner, I mean the true painter whose colour moves us by loveliness akin to Nature. Do not work the sky, time will do its effect. Watercolour, dread word: Why not Aircolour? The little blobs of glob soon dissolve into it.'

'I was an awful puritan too, in painting at any rate. I rather hope I'm not like that now, but I don't like trivia in painting. You try to keep asking yourself, "Does anyone need this picture?" It's the same with writing: there are too many bad pictures, there are too many bad books, and you mustn't add to them, unless your intention is right and there's a *chance* that you won't make things worse.'

Roger Cook succeeded Procktor as a Slade committee member on the student-run 'Young Contemporaries' at the RBA Galleries in the early 1960s: 'It was the first time we'd

seen the pop paintings of Hockney, Peter Phillips, Derek Boshier, Allen Jones and the rest of that Royal College generation,' Cook recalls, 'and it really shook us. We had no inkling of pop culture. The Slade instilled the belief that we were Fine Artists and when we saw pop we thought it was cheapening art by introducing graphic design. But it bowled us over and I think Patrick was quite affected.' Nevertheless Cook reckons Procktor had other, profounder, influences: 'There was van Gogh, and perhaps the distortion of Patrick's figures owed something to Giacometti, though I think more to El Greco. There was a wonderful fancy dress party at the Slade every Christmas with everyone trying to outdo everyone else and one year Patrick decided we should go as El Greco's *St Martin and the Beggar*, with him as St Martin, of course; though he swears to this day he was the beggar!'

Michael Upton, then at the Royal Academy Schools, first met Procktor as a fellow member on the committee: 'We became friends because of our rows with Peter Phillips and Allen Jones. I soon discovered that outside that persona of the "camp artist", Patrick has a great sense of humour and a fierce intellect. His early influence was much more literary than technical. Through Robert Medley he knew writers like Colin MacInnes and he could speak Russian. I always think of Patrick having a broader, more European, approach to the arts.'

In the summer of 1962 Procktor travelled through Italy and Greece with Michael Upton and his wife Ann, with the help of the Abbey Minor. 'It was really finding out about new cultures. Nowadays it would be commonplace. People do all that during their schooldays. But at that time we knew much less and it was still quite an adventure.' He remembers the two of them doing watercolours and drawing for the sheer enjoyment of it, though none by Procktor survives. Nevertheless, Upton feels this trip may have sown the seed for Procktor's subsequent mastery of the medium. The three of them hogged art as only the young can. Selection comes with age, when the appetite is less but taste more discerning. It was the frescoes from the Villa of Mysteries in Pompeii and at the National Museum in Naples which proved most influential, a solemn and rich combination of the abstract and figurative. He also used photographs as a visual aid for the first time.

Some of the work inspired by this journey, large figures in movement in a landscape, formed his first one-man show, at the Redfern Gallery in 1963. The show sold out before the opening. It was a *coup de théâtre*. Bryan Robertson, director of the Whitechapel Art Gallery, wrote the catalogue and spoke of 'metaphorical handsprings, somersaults and cartwheels which a young artist performs when he finds himself suddenly'. Kyffin Williams was also astonished: 'When he came to me for a recommendation to the Slade I have to say I was not overimpressed and gave him a B. I was amazed by the quality of the work at the Redfern.'

Procktor had assimilated the way Hockney and his Larry Rivers-influenced generation at the Royal College amalgamated the figure with abstract expressionism, but he added a verve and romantic passion of his own. The work was still Bombergian. Upton remembers it as decidedly so in its sombre, thickly painted colour; and also cites the influence of Keith Vaughan's male nudes and that of 'a curious lady painter who taught at the Slade, Dorothy Mead'.

Figures by a Pool (1963) exemplifies Bombergian gloom, while the intermingling of figurative description and formal geometry is reminiscent of Graham Sutherland. Its subject and technique even, to a lesser degree, its tone and composition, find an echo in *St John Baptising the People* (1984), his

reredos for the chapel of St John the Baptist in Chichester Cathedral. The paint in the later work is more lusciously applied in a style closer to the German expressionism of an artist like Corinth; but the sense of freedom is the same, and the tree and its shadow occupy the same position and fulfil the same restrictive function as the earlier vertical line. *Parade* (1963-64) is bolder. Its greens, olives and black have a Vaughanish tinge, but Vaughan would never have introduced the daring contrapuntal vase. The strangely beaked figure on the left has Procktor's unmistakable stance.

His debut remains his most sensational show, laying the foundations for his lingering reputation as a 'sixties artist'. Upton puts it in perspective: 'It may be his strongest show but I don't think it was his real work. I don't think he's a massive, sombre, painter. Lightness of touch, colour, sardonic humour are the authentic Procktor.' The paintings were complemented by some figurative drawings, slavish in their intense and hesitant debt to Cézanne.

The show did have two positive long-term effects. One was to consolidate the professional marriage with the Redfern which lasts to this day; the other enabled him to buy the leasehold of William Coldstream's flat in Marylebone, the Coldstreams having decided to move to Islington. The 'Pretty Flat', as Coldstream called it, was in a quiet Georgian backwater near where Procktor had lived as a child. It is a short walk from Odin's restaurant, whose artistic character was to be Procktor's invention, and overlooks public gardens where office workers pass their lunch times.

For 30 years the flat has been Procktor's inspiration, refuge and studio, so that today it constitutes a work of art in itself, not 'interior design', but the accumulation of a life. The walls are hung with pictures by himself and his friends; notably, a Hockney crayon, the low-key tonal paintings of interiors and still-life by Michael Upton, and a much-prized present of a cityscape by another old friend, Prunella Clough. 'You know she's so modest,' he says approvingly, 'that in her studio all her paintings are turned to the wall.'

In the 'loo' on the landing there are gold and platinum records for the cover of his album 'Blue Moves' by Elton John, a signed print by Sonia Delaunay, and a reproduction of a Matisse cut-out.

'I rather like Matisse. I think he was the best colourist of the century. He had an instinctive sense of lovely colour, even in those inter-War pictures which people rather put down – not predictable, not pretty, but true colour. Not pretty in the way d'Oyly John – (haven't you heard of him?) He's still frightfully expensive – not in the way *he* was pretty in his potboilers of the Riviera – any old colour, any old riviera. I don't rate Picasso as a colourist. He's too limited, too garish. By comparison Matisse's pictures are not at all obvious. Think of the *Piano Lesson*, it couldn't be less obvious colour, in fact it's mostly grey, but he makes it tell. Of course I would aspire to be a colourist; it's the greatest thing in art.'

Upstairs there is a set of rooms that might have belonged to a Bloomsbury dandy. The striking wallpaper is to his own design and reflects his love of Islamic art. It is a square pattern in apricot and grey, a cube turned on its axis, with a variation in monochrome. The paper is also used on a lamp shade. 'In Islam you're not allowed to copy nature. Allah said: "Thou shalt not make graven images; thou shalt only smoke 'Spot'" – you know what I mean? Everything was terribly dull. They compensated with Maths and tiles.'

The walls are covered with pictures, the most dominant his portrait of Princess Margaret, which she sat for in the drawing room which also acts as his studio. She is shown partially hidden by a Chinese screen and a pot of nasturtiums, wearing a grey silk dress, the material glued on to the canvas. It is

formal, as befits its royal subject, but in an informal way. 'I did it in response to a coming-of-age photograph by Cecil Beaton, which presented her back-lit against a ludicrous cloud of hydrangeas.' Off this room is the inner sanctum of his bedroom with its legendary wall of flowers, painted or drawn directly by his friends.

The 'New Generation' exhibition of 1964 at the Whitechapel Art Gallery, named and curated by Bryan Robertson, reinforced the impact of the 'Young Contemporaries' and Robertson's own 'British Painting in the Sixties' at the Whitechapel in 1963. It presented what were perceived as the most promising artists of the time: among them Patrick Caulfield, Allen Jones, David Hockney, John Hoyland, Peter Phillips and Bridget Riley. Pop and Op attracted the publicity, from which Procktor was the obvious exception. The show was followed in 1965 by publication of the documentary book *Private View* by Robertson and John Russell, with photographs by Snowdon. The book symbolised that era in British art as instantly as the Beatles' 'Sergeant Pepper' LP did for the pop music of the period two years later. Procktor had the accolade of a double-page spread:

'Extrovert, gregarious, sharp-witted, and intellectually both serious and well versed,' wrote Robertson, 'Patrick Procktor at twenty-nine has a keen satirical and theatrical sense as well as a concern for the reality including the tragedies of life … Procktor relishes what he calls "the open situation" that now

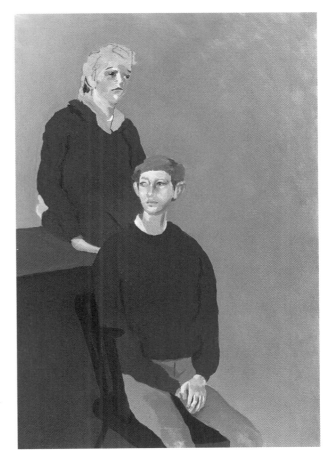

Nicholas and Nicholas 1987

exists, stylistically, in art everywhere; and he is sufficiently eclectic by nature to make skilful and intelligent use of this situation and to exploit its potential freedom of expression. But committed as he is to figurative painting, this freewheeling can easily lead to superficial and unconvinced references to abstraction, from which to bind together the figurative elements in a composition.

'He has learned from other figurative painters in England: Vaughan (his teacher at one time), Bacon, Hockney, and above all from Kitaj. All these artists are trying to find the answers to similar problems, the main one being an attempt to project a new image of man in a relevant and meaningful context without relapsing into a devitalized and academic formula or accepting total abstraction.'

To paint 'decoratively' was as heinous an art school crime as to be illustrative. To be serious was to be all doom and gloom, therefore unsaleable. In a perverse way the English love of underdogs resulted in the twisted notion that success was failure, a sell out. Poverty was a mark of moral rectitude, an idea exemplified by the neglect and straitened circumstances of Bomberg in his old age. Decorative art was thought 'tarty, pandering to taste'.

Clover 1987

Through Upton, Procktor met David Hockney, who became a close friend. In the public mind the two were an inseparable symbol of the Swinging Sixties; as glamorous a duo of peacocks as the London art world had seen. They joined Upton as part-time teachers at Maidstone School of Art. 'Lightness and humour came into his work around the time he met Hockney,' says Upton. Large canvases in quick-drying water-based paints were now possible thanks to the invention of acrylics in 1964. For his 1967 show at the Redfern he used acrylic on canvas for the first time. They were figurative works but done on the large scale made fashionable by followers of American abstract painting. Swiftness of execution required risk. The imaginative freedom of Surrealism had returned, as it has again in the 1990s. Procktor's explicitness was a mark of confidence. 'Where did you find all those leather queens?' Asked the man from the *Daily Mail*'s 'Picture Probe', showing a keen personal interest.

In *Hallowe'en* (1966), Procktor and some friends, (Hockney in a dress), pose in a room reduced to three colour bands in the form of the then fashionable hard-edged New York abstraction. Like Hockney, he decided to be less selective as a painter, less precious and elitist in the snobbish modernist way, and to have fun. They were both passionate lovers of opera, and both were to design for it. *6 AM at Heaton Hall* (1966) could be a stage set. It was possible to be decorative again and to use art in a conversational way. To paint in tune with the youthfulness, the carefree optimism of the 1960s, a butterfly time after military restriction (like the 1920s), was now possible, though few who had experienced conscription regretted their two years of National Service with its often productive consequences. Procktor, if not strictly a pop artist, certainly came to reflect the hedonism and motley of the pop era in which he played a notably active social part. He even did pictures of the Rolling Stones in drag, one of which was used for the cover of their single 'Have You Seen Your Mother Baby'.

The critic Mario Amaya called him 'the Parmigianino of Pop' (which Procktor took as a compliment, Parmigianino being one of the earliest and most elegant of the sixteenth-century Mannerists); but he was never a pop artist in the true sense of celebrating consumerism, even if he was an enthusiastic participant in the fashionable frolics of the time. Among his closest friends were the designers Michael Fish and Ossie Clark. He frequented the parties and private views of the antiquarian Christopher Gibbs, one day as curly-topped as Harpo Marx, the next the first West End skinhead, and was often to be seen at the avant-garde gallery owned by Robert Fraser.

Gibbs was renowned for his wit – '"Wild Strawberries" wouldn't drag me,' he replied, when refusing an invitation to the latest Bergman film – Fraser for his cool; he had renounced communism by the age of eleven. Procktor's romantic allegiance to the Red Flag lasted longer, but though he remains a socialist he believes that political comment in art is for the cartoonist. 'Marxism is *the* political philosophy of the century and the one that's bound to predominate,' he said in *My Britain*, a year before the collapse of Russian communism. 'Funnily enough once you sit down to paint all that falls away', he said.

In 1966 he was invited by Shrewsbury School of Art to organise a landscape-painting excursion for the students. He arranged for them to go to his friend Michael Duff's estate at Vaynol in North Wales, where they pitched camp in the park while he enjoyed the comforts of the house. For convenience he took watercolours and painted landscapes and portraits. Vaynol was an important refuge; and he spent many happy weekends there, often in the company of Cecil Beaton and John Dewe Matthews, both as keen to pass the time painting as he was. Dewe Matthews recalls how keenly they worked, so much so that Michael Duff, who had serious problems in finding a six o'clock drinking companion, complained: 'I'm so looking forward to next weekend because none of them are artists!' Even after being semi-paralysed by a stroke Beaton still battled on with his art, despite his helper invariably putting his spectacles on upside down and his having to paint, or, more usually, to draw with his left hand. 'Patrick was so generous and amusing about Cecil's inevitably feeble efforts because of the paralysis,' Dewe Matthews recalls. 'I went again after Cecil had died and Patrick cheered us up at dinner when he said: "I expect he's photographing God by now!"'

The following year he took watercolour equipment on a trip to France and Italy with David Hockney. This time he was hooked. 'It is a medium in many ways like printmaking,' wrote Hockney in an appreciation of his friend in 1989. 'You think in layers backwards, the white of the paper has to be used for clear colours, and not too many layers can be used as it is not opaque. It can have great ranges of colour, and yet all the equipment can be very small and Patrick preferred the bijou box – it fits perfectly on his knee.' 'It was a regression,' Procktor told David Gwinnutt. 'I hadn't touched watercolour for years until 1966. I came to it because my paint got thinner, and I was playing around with acrylic, which was going onto the canvas like a wash, so the natural regression was to watercolours. Effects that had been difficult when I was little, suddenly gelled.'

In 1968 Procktor wrote an article in the *London Magazine*, 'A Return to Watercolour', arguing that water-based acrylic painting, made fashionable by the pouring and staining techniques of American abstract painters, was only watercolour on a grand scale.

'Watercolour has no body. The body is in the forms. Watercolour paper is of course non-porous and without sinking the particles of colour lie in little pits lit from behind by the white paper, offering themselves to the eye with no barriers between (no impastos, no trailing hand, no varnish, etc). See how burnt sienna and ultramarine war and separate as they dry – it is a small miracle, like a huge Olitski in microcosm, a marvellous malachite or a pointillist happening for elves.'

For Patrick Procktor the technical interest of watercolour lies in its translucence and directness; its opposition to gesture and bravura; its accident proneness. The brushstroke dissolves and vanishes.

'I think he's a marvellous watercolourist and aquatinter,' says Christopher Gibbs, 'it suits him. There's a lot of water in general in his life. He likes to leave things sloppy.'

Procktor studied the Boningtons in the Wallace Collection with particular attention. 'In Richard Parkes Bonington there is a perfect tightrope between washiness and vision, the effect is transparent to the subject. He is the purest of watercolour painters and the least interested in imprinting himself on the subject.'

The first of his many watercolour shows was at the Redfern in 1968. It included named portraits for the first time of Mick Jagger and others; the 1966 portrait of Jagger drawn in felt-tip pen was bought by those no less iconic figures, the living sculptors Gilbert and George, when they were art students.

Hockney was making portraits too. They were both changing from experimentation to naturalism, from the imagined to the observed image, preferring to paint friends than to undertake commissions. They made portraits of each other, Hockney's being a full-length masterpiece of Procktor (today on loan to the Scottish National Gallery of Modern Art).

'In 1967 Patrick's studio looked clean, neat and office-like. The next year it looked like a den in the Casbah – it seemed to change as often as Auntie Mame's,' wrote Hockney in 1989. In response to 'Flower Power', the slogan of 1967, he stripped and primed the front room of his flat with the help of Mo McDermott, then the close companion of David Hockney, and painted flowers on the wall. Intrigued artist friends were invited to contribute. Hockney, Kitaj, Cecil Beaton and Mario Dubsky all accepted the challenge; Frank Auerbach added a frightening tulip, surely unique in his oeuvre. The wall remains, an eccentric legacy of a now historic era.

One May Day Procktor drew the most fashionable playwright of that year, Joe Orton, who was murdered by his boyfriend three months later. Orton's diary records the genesis of the famous drawing of him in the nude with nothing on but a pair of socks; more brazen than Hockney's painting *The Room, Tarzana* (1967) where the boy lying provocatively on the bed wears a shirt as well as socks.

'At 4.30 I had to go to Patrick Procktor's studio in Manchester Street. "To be drawn," Peter Gill (theatre director) said. "Have you been to his exhibition?" "No," I said. "Oh, it's marvellous. There are terrific drawings of the Rolling Stones in drag. And paintings of Chinamen. And wonderful ones of young boys in their pants." "Perhaps you'd like a picture of me without my clothes," I said. Peter's eyes lit up. "Would you mind?" "We'll be delighted," Peter said. "Ask Patrick – he's very grand, you know, it's a great honour that he should consent to draw you." … Peter had said, "You've got to interest him and then he'll do a good drawing." "Did Peter say what kind of drawing?" P. Procktor said. "Well, it's no use just doing a conventional portrait," I said, "because there'll be photographs in the programme and you don't want to compete with them. Peter said to tell him that you can do anything you like. He even suggested I take my clothes off." "Would you mind?" he said. "No, not at all," I said. "Well, we'll do one or two with your clothes on. And then you can take your clothes off." He paused and said. "What music do you like? Do you want to listen to pop or classical?"'

It shows how unswinging the 'Swinging Sixties' were, that the drawing caused a furore when it was published, so much so that for a long time after Procktor was best known for this one small picture. Orton's entry for 23 June includes: 'Showed Pitman (Sir Hubert Pitman, businessman) the Royal Court drawing by P. Procktor. "With every programme we gave away a nude drawing of the author." He stared, alarmed. "Not like this one?" he said, looking at the drawing. "Yes," I said. "Good heavens." He looked shattered. "What one can get away with nowadays."'

The sitting had a strange postscript a quarter-of-a-century later when the feature film of Orton's life, *Prick Up Your Ears*, was made. The studio at Manchester Street was recreated but so overdone that when Procktor saw the film he said he yearned for dark glasses! Derek Jarman, a very short man, was playing him, standing at an easel instead of sitting down to draw and carrying his brush in his right hand. It was this lack of recognition that he is left-handed that was the only fault Procktor found annoying. The film itself he liked, especially Alan Bennett's script. At the end there is a scene where the ashes of Orton and his lover Halliwell are being spooned into a single urn by his sister and Peggy Ramsay, his agent. One loses count of her spoonfuls and the other snaps: 'It's a token, dear, not a recipe'.

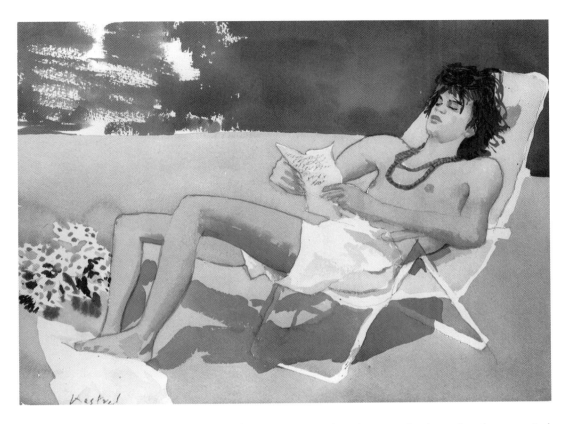

Kestrel Boyle 1989

Procktor was criticised for his lack of consistency in choosing to paint in such a 'conservative' medium as watercolour, for moving from a promiscuous approach to a more defined one; but he resists being cornered. With Delacroix he believes inconsistency is a virtue.

'You can always stabilise painting by attaching yourself to the rock of observation. At the time it was necessary for my development as now it is not. And you create new means for expression in observation. I couldn't have painted from life on the first trip to Italy, nor in Greece, nor in America, but there was a point when the single viewpoint both limited and concentrated the expression of self.'

'You never succeed in capturing the real. The most brilliant realist doesn't succeed, not Lucian Freud, not Bill Coldstream. I wanted to entertain the viewer, to have points of intensity and humour, and for the viewer to go along with the attempt, and its inevitable but comic failure to capture the world. However hard you try the one thing you can't escape is wishing that this picture will be perfect, but you make the first brushstroke and you've made a mistake.' In the words of W B Yeats: 'The painter's brush destroys his dreams'. It is the pain in painting.

One aspect of watercolour did dissatisfy him. Nothing in it derives from struggle, at least not through a struggle on the paper. It either works or it does not. If it does not, there is no point in persisting. You start a new painting. The whole point of the medium is its magic, that the result has not been willed at all. It is certainly the prevailing characteristic of his own work. 'In watercolour you go from light to dark. It sounds so dull, so cerebral, but it's instinctive. The only thing that matters with pictures is instinctive. No one taught me, not one. In art school they were dead against it. You start with the whites, the raw paper, because you can't replace it and the whites have to sparkle; and then you look

for the next tone down, and so on. You have always to work from light to dark. It's your first instinct with the page, otherwise you can't paint watercolour at all.'

The following year Procktor went to Morocco for the first time. He was immediately captivated like so many artists before him – Delacroix, Klee, Matisse, Lavery, McBey (whose wife the painter Marguerite McBey became a friend and, in 1997, is still the doyenne of the artistic community): 'one yearns for direct inspiration from nature and the moment you step off the plane at Tangier it is there; the colour, sound and scent is offered to you. Even from your cab, you feel that you're in the Bible.'

It was Lavery's Moroccan pictures, first seen at Michael Duff's, which inspired him to go; especially one of the Casbah at night, the lavender pink of the glowing walls suggesting the retained heat of the day. In Morocco it is impossible to sustain the belief that art cannot be decorative. Pattern is everywhere. So was it to be in Procktor's art. In the case of *Skull* (1976) and *A Ghost in the Alhambra* (1987), the very same pattern in different contexts appears after a gap of ten years.

It was at about this time that a startlingly attractive young man called Gervase Griffiths became a fixation. Procktor painted him almost exclusively for two years in watercolours and large acrylics, based on photographs, some of which were taken in Regent's Park with Gervase performing handstands, cartwheels and headstands. Further sets of photographs were taken by the ever-fashionable Cecil Beaton, nicknamed 'Rip Van With It' by Christopher Gibbs. Procktor still sometimes uses these Beaton photographs as the basis for paintings.

The English are uneasy talking about beauty, particularly when it is a man complimenting a man. What is commonplace in classical literature and Arabic countries is the rarity, even in poetry. 'It has that fragrance of the *fin de siècle* and all those sticky sonnets. But I did find a good poem in English the other day, the one Siegfried Sassoon wrote to Stephen Tennant on his twenty-second birthday, which says it better than I can:

'Because today belongs to you by birth,
For me, no other day can ever bring
The wildflower wonderment of waking earth,
And so, till now, I have not seen the spring.'

But in the 1960s Englishmen were allowed to flaunt their beauty in a way forbidden since the days of the beaux and bucks of the Regency, 150 years before. Procktor celebrated this efflorescence more sympathetically and elegantly than anyone. 'It is no mean compliment to say of an artist that he sums up in his work the age in which he lived, ' wrote Richard Dorment in *The Daily Telegraph* in 1987. A gentle age, at least in aspiration, it suited Procktor. 'I'm a very unaggressive type. I realise now that I'm really a tolerant person. I can understand so much of what people do and say,' he told his interviewer for *Art and Artists* in 1974. This tolerance has not diminished with the years; at heart he remains in the 'Age of Aquarius'. It made jury service a painful ordeal for him 22 years later. 'You should have seen that stare, it haunts me,' he said of one man condemned to eight years in prison. He gave vent to his revulsion by painting the scene from drawings done illegally in court.

By the end of the 1960s he had extended his range to include theatre design, for Christopher

Hampton's play about Rimbaud and Verlaine, *Total Eclipse*, at the Royal Court; he designed book covers for a Penguin edition of George Orwell and devised a 'poster poem' by Adrian Mitchell, a visual invention of the poet Christopher Logue.

Large acrylic paintings of Gervase Griffiths formed his 'one boy show' at the Lee Nordness Gallery in New York in 1969. The exhibition had a lukewarm reception, consolidating his 'notoriously snooty' view of American taste and art, which he considered – and still considers – provincial; a view now gaining acceptance, even in America. The experience was nevertheless productive, persuading him to do smaller and more mysterious paintings and to draw laterally from page to page through a book in the oriental style. On his return he worked his American drawings into large watercolours.

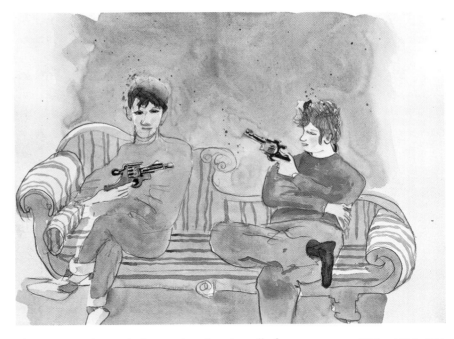

Will and Nicky 1989

'I worked from the drawings using the obsessive premise of isolating elements of the drawings and enlarging them, so the figures are not in scale with the still-life elements, the flowers, nor with each other. To start with one small segment of experience, and to dwell on that only, from afternoon into evening, and with evening the moon rising over Central Park in the reflection of the mirror.'

Richard Buckle was particularly impressed, describing them as: 'Flower Children dreaming away narcotic noons and a tangle of hallucinatory tulips, the windows of their Olympian penthouses fast closed against the expensive cloudscapes of New York'. They were less naturalistic than the later watercolours, delighting in imaginative play. I remember visiting the studio about this time and being shown a sweeping seascape which nonetheless had a title which suggested its principal subject was a fish. 'Can you see it?' he asked. The fish turned out to be very small and flying at an impossible height through the sky!

Joe Studholme of Editions Alecto also admired the watercolours and commissioned Procktor to make his first aquatints, a natural progression which surprisingly he had not tried before. He quickly mastered the technique explained by two expert young printers, Danyon Black and Maurice Payne. The process of converting the drawings to the watercolours was repeated. Things went so sweetly he ended up doing the largest prints possible on Alecto's presses, 2½ feet wide. He completed a suite of five which were published as *Invitation to a Voyage*, five poems from Baudelaire's *Les Fleurs du Mal*. 'He pushed the frontiers of aquatint,' says Christopher Gibbs, 'in the sense that there was more aqua than tint.'

* * *

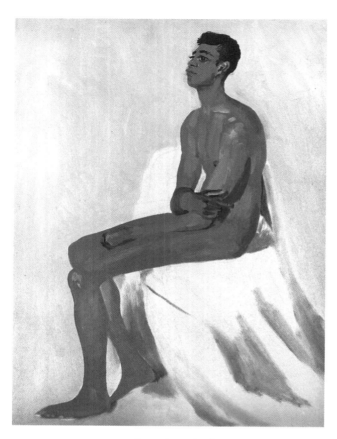

Darren 1988

The beginning of 1970 was spent on a solitary first visit to India, armed with poetry books. He kept a diary and transcribed the following from Coleridge's *Biographia Literaria*: 'The two cardinal points of poetry: the power of exciting the sympathy of the reader by a faithful adherence to the truth of nature, and the power of giving the interest of novelty by the modifying colours of the imagination. The sudden charm, which accidents of light and shade, which moonlight or sunset diffused over a known and familiar landscape appeared to represent the practicability of combining both.'

From the watercolours done on the trip a suite of aquatints, *India, Mother*, were printed as before at Editions Alecto. India showed the immeasurable advantage the eye has over the photographic lens. The colour between, say, the shade of a porch and the garden outside is lost in a photograph, the camera having to be set for shade or light. In painting, the colours of everything can be caught as the eye adjusts and responds. In the aquatints he dispensed with line, imitating a technique perfected by Goya, bringing the process even closer to watercolour. Procktor looked for romantic light in India, sometimes using as many as a dozen colours in a single print to capture it; but he is careful always to provide a resting place for the eye in incident or detail, however strange or empty the scene.

In the early 1970s he travelled a lot with Kirsten Benson who, with her husband James, had founded and run Odin's restaurant. The Bensons lived in the flat below Procktor's in Manchester Street and they and their children, Edward and Juliet, had become his friends. When James Benson was killed in a car crash in 1966, Peter Langan, another neighbour who had patronised the restaurant, gave up his job as a salesman to take over the day-to-day running of the business.

Langan found notoriety when he opened Langan's Brasserie in Mayfair, in partnership with the film star Michael Caine, and could sometimes be found sleeping off a good lunch on the floor of the ladies' toilet or crawling under the tables biting unwary customers' ankles; but Odin's was the prototype: its Parisian style, continued at Langan's, owed most to Procktor. In the words of Langan's 1988 obituary in *The Daily Telegraph*:

'Odin's became the works canteen of such artists as Francis Bacon, R B Kitaj, Lucian Freud and David Hockney, as well as Procktor. In the manner of a *Rive Gauche* café proprietor, Langan would exchange meals for the painters' work.

'Procktor's mural of Venice is in the upstairs room at Langan's Brasserie; and he also designed its distinctive menu, on which a blue-faced Langan looks bemused while Shepherd (the third partner) appears concerned to separate him from an admonitory Caine.'

A filmed vignette of Langan survives in *My Britain*, where he is seen talking to Procktor over lunch at Odin's. His quiet and kindly demeanour is more true to the man than legend suggests. He recalls the days when the standard Odin's complaint was 'Waiter, there's a Hockney in my soup!' and he confirms that Procktor was his first artist customer, who introduced Hockney and the others and turned it into 'an artists' caff'. He also extols the virtues of a nearby Procktor with the telling observation: 'Pictures don't have to be big, they have to be subtle'. Procktor has been described as the thinking man's Hockney.

Another portrait of Langan, an excellent likeness, decorates the menu at Odin's and Odin's Bistro, where Procktor's pictures are also to be seen among the many which adorn the walls. The other Venice murals were painted over by Langan, not in a fit of pique, as Brian Sewell wrote in his biography, but from fear of what he called the 'ghost ship'. Procktor found this a reasonable excuse. He loves 'haunting' in a picture.

Kirsten Benson and her children Edward and Juliet had continued to live in the flat and a sense of dependence grew between them and Procktor. Their first foreign trip together was to Venice in the winter of 1970. A heavy sea mist thickened by pollution made the city especially magical, so that buildings loomed and disappeared mysteriously and nothing seemed to be where one expected it. It is hard for an artist to wring anything new out of this most hackneyed of subjects, but Procktor succeeded from the outset; on this occasion by concentrating on such examples of the disregarded obvious as the light patterns made by the floating rafts where people wait for the water buses. No artist makes one more aware that Venice is perched on the sea.

Back in London he realised his Venetian watercolours as oil paintings, following them as closely as possible to retain their sense of spontaneity. He found it impossible to make it look as if they were done on the spot – at least impossible to his demanding eye – but there were compensations. Oil is richer in colour and, unlike watercolour, the hue does not diminish the farther you drag the brush. 'It's a kind of game, because you can reproduce a composition down to the code letter on the ship's buoy and the placing of a seagull, but there is a violent variation of colour and density in the translation. The buoy or the seagull is a souvenir of the original impression which survives into something that has become entirely different.'

To the modernist art world painting pictures of Venice compounded the error of his conservative return to depiction; with the result that even in 1997 he is scandalously unrepresented by a major work in the Tate Gallery. For him the experimental had become the status quo and it was more daring to rival rather than rubbish tradition. His attitude is confirmed by etymology. Experiment and experience share the same root. Experience and Coleridge told him that to paint the subjects that inspired him as truthfully as possible was his only course. His return to figuration took place at the nadir of its post-war popularity, painting itself being pronounced dead by the avant-garde establishment. But it anticipated the 1980s, when painting stormed back with an orgy of figuration after the starvation diet of Minimalism and Conceptualism.

His first show of Venetian pictures sold well and confirmed him a worthy successor to a long artistic pedigree, which includes Bonington and Turner among the great English watercolourists he so much admires. ('And what did Turner say: "If Tom had not died, I would have starved",' he says, wryly referring to Girtin's death at 27.) The opening was included in an autobiographical film of David Hockney, *A Bigger Splash*, which had a *succès de scandale*. Hockney is heard discussing one of the

paintings with Procktor. 'Did you paint this in Venice?' he asks, to which Procktor replies: 'No, in the basement at Manchester Street.' It was not meant as a joke but it always got the biggest laugh of the film.

He also exhibited what has become his most famous and, at half life-size, his largest portrait: an appropriately theatrical oil of Jill Bennett or 'Jill Benight', as he teasingly called her, in a scarlet Jean Muir dress, as bold in colour and design as a Matisse, with legs as elongated as a Boldini in the high summer of Edwardianism. Patrick Kinmonth, in his book *Patrick Procktor* (Cavallino/Venezia, 1985), describes her pose as 'a draped cross', a haunting description considering her later, suicidal end. Procktor's own taste for the theatrical responded to his subject, whose appearance he found compelling: 'She was so ugly to me at first. Not just a plucked and scrawny chicken but one that had had its bones picked. But I soon grew to admire her looks. People who are just beautiful are repellent.' The portrait took eight weeks to paint while she was playing Hedda Gabler in Anthony Page's production at the Royal Court. 'One day she commented that there was something "very strong" about the way I worked. I melted, it was such a compliment.' Through the painting she became close friends both of Procktor and his wife, invariably coming for New Year's Eve or Christmas until the end of her life. The portrait was bought by her husband John Osborne. 'John came and I hung it and he said "It's brill". Money was no object and he bought it there and then and took it away. Then they fell out and so he took down the painting, turned its face to the wall in his hall and threatened to put his boot through it every time he passed it so much did he hate her! Eventually I sent a van and took it back and it stayed here for 20 years. So not only did I paint it but I had to rescue it from destruction.'

In his private collection Procktor has another portrait of her, a profile with a large piece of costume jewellery fixed to the canvas. The forehead to the tip of the nose forms a flawless curve. 'They used to call it the "ski-jump" back stage. It was quite extraordinary. It just went "whoosh".' He has fun with portraiture, and laughed uproariously when it was suggested that in his picture *Ossie Clark* (1994), it looks as if Ossie has set light to the painting.

His 1987 portrait of his old friend, Roger Cook, vies in its scarlet brilliance with the large Jill Bennett portrait. Roger Cook relates: 'He knew I was doing some work as a male model, and there was an absurd chat show where someone said I looked like Van Gogh, and he thought all this was hilarious. "Darling, I've got to paint you!" he said. I agreed, but to make things more difficult for him, I wore this brilliant red jacket. Of course when I arrived I found he had already trumped me by painting the background viridian green! I ate an apple and he used that too, setting one green off against the other. He can be a very risky colourist; in fact his most eccentric pictures are often his best.'

A similar wit animates *'Revolution 1905'* (1986). Two naked feet are provocatively placed on a Russian headscarf proclaiming the first, suppressed, communist revolution. A picture of workers bearing the red flag is accompanied by the slogan in Russian 'Glory to the Strugglers of the Revolution'. 'It's the naked foot of Nanny – a male nanny – when Nicky was about 12. It's nothing to do with Nicky, except these are his Nanny's feet. Nanny probably didn't have anything to do that evening. It's a coded message, but I'd say it was someone stamping on Communism. You can see the trampled people.' As a political statement it is teasingly ambiguous, because we do not know what the nanny symbolises; and if Procktor knows, he is not letting us into the secret. He would make an immaculate spy: code name Oscar McTaggart.

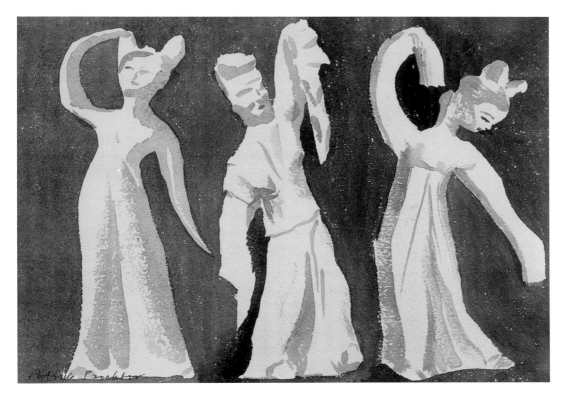

Turandot 'Ghosts' 1984

It was another actor, Terence Stamp, whose portrait he had also painted, who suggested he should return to Morocco to stay at the Palais Jamai in Fez; once the palace of the Grand Vizier, in 1972 it was still the world's most romantic hotel. He took Stamp's advice and made the second trip with Kirsten. They stayed at the hotel amid its tiers of terraces and gardens. Procktor preferred the lowest, 'Favourites', courtyard, delighting in the beauty of the mathematically sequential tilework, the shading orange and lemon trees and the quiet fountain. Decorative traditions had always interested him but the Islamic fascinated him more than any other, amazingly direct for all its complication. 'All Arab maths is based on odd numbers 1,3,5,7,9 and all the beauty of Islamic design is based on it.'

As on his previous visit he also stayed with Rex Nan Kivell, now retired as director of the Redfern, at his beautiful house at El Farah, where the painter John Craxton cooked an amazing aubergine lunch and led them in a wild roundel of Greek and Moroccan dances.

At Christmas he visited Kirsten's family in Copenhagen, a visit which resulted in a panoramic view over the city from his hotel in consecutive paintings, to be placed in order on the four walls of a room.

They married in 1973, returning to Venice and Florence for their honeymoon. In London he painted her as *Diana the Huntress* after a painting by Lely, wearing a jewelled crescent moon in her hair and holding a bow. Roy Boulting, the film director, bought the picture. The half-moon and the bow were invented, but afterwards he bought her a present of a real eighteenth-century half-moon piece of aquamarine, tourmaline and gold. His portrait of her wearing this piece was hung at the Royal Academy Summer Exhibition. Cecil Beaton saw it and told him he had stood 'for 20 minutes rocking with laughter'.

Their son Nicholas's birth the following year prompted a tender series of watercolours done at the bedside. Their delicacy powerfully expresses the emotion and wonder of parenthood. Nicholas

accompanied them not long after to South Africa. Apartheid required the Cape Coloured model to stand obediently on the doorstep, until the white occupant led him in. Procktor pointedly called his resulting portrait *Non-white*, the dismissive name for Cape Coloureds. Procktor may not be a propagandist but he is a moralist and his wit can be politically acerbic. Editions Alecto published a suite of etchings based on the trip; the success of these has led to a succession of Alecto commissions at regular intervals since, based on trips abroad. It also led to the highly acclaimed Alecto publication of his first illustrated commission, 12 aquatints to accompany Coleridge's poem *The Rime of the Ancient Mariner*. Among the public institutions which purchased this work was the Museum of Modern Art, New York.

The *Ancient Mariner* was launched with a Redfern show in 1976, along with a selection of earlier aquatints and some flower paintings done in Ripolin enamel paint. Bernard Denvir wrote a review in *Art and Artists* dismissing Procktor as a 'boudoir' rather than a 'salon' painter. Denvir exhibits a very English form of masochism, the sweet torture of agonising over his enjoyment: 'If one accepts Procktor's art at its face value – which he would have us do – we find contentment for the eye, and titillation for the imagination, which perhaps is all we should expect. But at the back of our minds is always the feeling that we need the visual arts to extend us; that they must be demanding in a way which only the most advanced music or literature is. Pleasurable acquiescence is not enough.' One is compelled to ask if the Minoan *Spring Fresco* of lilies and swallows from Thera is 'demanding'. Or trecento painting? Or Gainsborough? Or a Manet rose, or a Matisse cut-out? For Procktor the idea of dismissing something for being pleasurable is lamentable: 'I don't see why a painter should paint something which isn't decorative. Do we know a single painter who paints well but does not paint beautifully?'

Francis Bacon once confided to him that he regarded putting on paint as the same as putting on makeup, the same techniques to the same beautifying ends.

Procktor makes light of his travels, saying that for his landscapes he would be content 'to be sentenced to Kensington Gardens for the rest of my life. It's far more beautiful than most places in the world.' But as a young man he once went on a six-week Peace March through Byelorussia to the Kremlin, where he had tea with Mrs Krushchev; and in 1980 he was the first Western artist granted permission to paint in Communist China. He had nine drivers, nine guides and freedom of movement, travelling via eight cities from Canton to Peking, by way of the lunar mountains of Kweilin and the rock gardens of Su' Chow. Pleading lack of time he managed to avoid most official chores. Inquisitive onlookers were a problem when he painted and his favourite spots were the walled gardens, open to the public but closed in the evenings when he was granted privileged access. One of the 99 gardeners tending the grounds of the Imperial Palace was the last Emperor. Procktor asked which he was. He was told he was the one who did not spit.

'I had a very fixed mind in China. I lived on one bottle of whisky a month from the Friendship Store. You could paint as long as you liked every day in this extraordinary light, with only distant telephone contact with the outside world. I even hung about in the lobby to pick up someone to have dinner with in these cavernous dining rooms designed to sit 900 people. China taught me more than Japan,' he says. (He visited Japan in 1990.) 'They're terribly bad painters, the Chinese. Our painting, European painting, has much greater richness, much greater range in orchestral terms. I'm thinking, for example, of those magnificent 60ft tall Rubenses in the Antwerp Museum, which is the most wonderful art gallery I've ever seen. But I don't mean to dismiss the Chinese. What they do have is this wonderful vision of their own landscape, which goes on into the scroll. The scrolls were unsigned; the only

intrusion was the emperor's stamp of approval. And, of course, they excelled in science, in porcelain, in calligraphy, in sculpture.'

To sum up the 1980s he quotes Maggie Thornton, who began at the Redfern in the 1960s as Rex Nan Kivell's assistant and is now its director and what Procktor calls 'The Picture-Dealer Extraordinary': 'We think you were very productive in the 1980s'. The period included a number of important commissions, at home and abroad.

Corporal R J Ransome, 1 Royal Anglian (1983) is one of the series of paintings recording the British Army in Belize, British Honduras. 'He was the Brigadier's "tiger". The painting was done under very difficult circumstances. Twenty-five officers and their wives came to view it and Corporal Ransome mixed the dry martinis. He had tried some samples on me before. "Is it strong enough, sir?" he would ask. Eventually he said: "I think it is strong enough, Mr Procktor"!' Today the picture hangs in the Imperial War Museum's Reading Room.

The same year saw the blessing of his reredos or altar-piece for the chapel of St John the Baptist in Chichester Cathedral. Procktor is not a regular churchgoer and the commission nagged at his conscience until he saw Poussin's *St John the Baptist Baptising the People* in the National Gallery, Washington. 'Poussin was a neo-Platonist, a modern man, and I could see how he had painted the subject, not as an act of unquestioning piety but as an expression of his personal philosophy. It showed me the way. Of course you hope, I hope, we all hope in the Resurrection and that we'll be reunited with those we've loved.' The Dean and Chapter told him that when Piper's garish tapestry had been unveiled behind the high altar one of their number processed at the commemoration in dark glasses.

Ma Griffe 1994

There was a lengthy but eventually frustrated commission to design *Turandot* for the Royal Opera House and a public commission on behalf of the British Council to record the Queen's state visit to Portugal in 1985. But there was also the great sadness of the death of his wife. His autobiography *Self-Portrait*, published by Weidenfeld & Nicholson in 1991, peters out with the death of Kirsten in 1984. In it he says he still measures his friends by the regard they had for her.

It was after she died that he first went to Egypt, a country he found beautiful and inspiring. At first the light was perplexing, one minute making colours stronger, the next bleaching them out. The clothes, the landscape and the sunsets were more colourful in India. 'There's nothing more exciting than a woman coming out on to a terrace in a sari in the sunset. That's colour with a bang,' he told Gwinnutt; but on the other hand, in Egypt, 'the ruins and noble architecture make our architecture seem very puny.' His watercolours, as if in sympathy, were his largest, 18 x 24 inches. *Cataract Terrace, Aswan* (1984) makes a feature of the patterned blinds; feluccas steer round Elephant Island: the famous dam is out of sight to the left. 'This is just below the dam. It can be placed autobiographically as well as topographically where you were, what you were doing.'

He made oils on the spot and, back in London, inspired by Egyptian monumentality, painted a 'ceiling', 120ft long and 16ft wide, for the Henley Festival, where he turned a tent into a pharaoh's tomb. The piece was also shown at the Harris Museum, Preston. There is a foretaste of this influence of Ancient Egyptian murals in the frame painted with a pattern of Egyptian devices which surrounds the

Le Baiser 1994

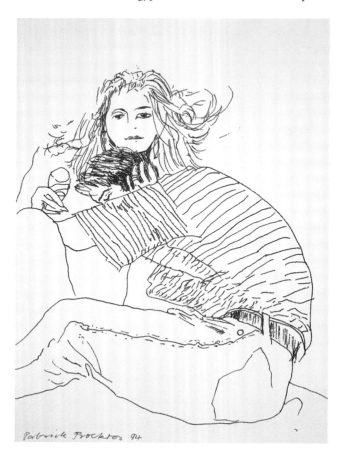

contrastingly spontaneous *Peter in Luxor* (1984). Is there a touch of early Jack Yeats about its figure on the threshold and the racy brushwork? 'I don't know, but I adore Jack Yeats! I first saw his work at Victor Waddington's gallery on Cork Street and thought it wildly exciting. Jack Yeats could conjure anything. First of all he did wonderful drawings of jockeys and stable lads; and then he turned into a visionary genius.'

My Britain is a poignant record of 1988, featuring such close and now departed friends as Jill Bennett and Peter Langan. It paints a melancholy picture with a soundtrack of Procktor playing a slow and wistful blues on the piano; but ten years later it has not dated one iota. This local celebration was followed in 1990 by his first visit to Japan. He was no more impressed by Japanese art than he had been by Chinese art in China. 'I like Utamaro, those incredible hairstyles, and Hokusai, and that one that begins with 'E'; but the same thing applies. Their painting lacks the grandeur of Western art.' Nevertheless the trip was highly productive. Clearly Japanese sensibility, not least the love of flowers, suited him. The pleasing minimalism of the grisaille watercolour, *Daibutsuko Brush* (1991), of a Japanese paintbrush, brush holder and water jug, is a signature of approval; its brushstrokes

no more numerous than the seconds it took to complete. It has its figurative equivalent in *Self-Portrait* (1996). And there is a Hokusai touch in the 'stair rods' of rain which bar the view of *The Golden Temple*.

There was also something fishily Japanese about *Spike*, his winning entry for the Singer & Friedlander/*Sunday Times* Watercolour Competition in 1991. He explained its subject in *The Sunday Times* magazine (15/9/91): 'It's a crayfish. I went and bought it at the fishmonger's one day and it lived on the piano for six months. I made some dreadful mistakes. I put it in with the goldfish, which of course it devoured. And it had two marriages, if that's the word, both victims of which it devoured. But it was very enterprising. It used to go all over the place; people used to find it in the morning a great distance away by the window. It's not easy to understand a crayfish, unless like me you're a Piscean – in which case you'll probably get eaten.'

Portrait of a Young Man (1991) was done on a painting holiday to France. It is of Richard Selby, a Redfern director, who remembers it taking two four-hour stints on consecutive days to complete. 'It was very hard work. He painted it flat, not on an easel. It looked dreadful from my angle when he was painting it; but when I saw it right way up, the hairs stood on the back of my neck – it was so true a likeness it was like looking into a mirror! The watercolour portrait of me was a far more casual affair. He works with great speed in watercolour. *Rose* was done on that holiday and I doubt if it took him more than an hour. We were all painting and he didn't mind us watching how he did it but he hates explaining or talking about it.'

This is true, but sometimes he relents just a little: 'The blackest black is the bird on the vase and all the surrounding ones are just shadows of it,' he says of *Hirondelle*. 'If you've got one black you must keep it and all the other blacks must be melted down. It draws the eye. It would be less dramatic without it.' An old lady, who was very punctilious about plants, kept pestering him while he was painting *Hirondelle* to name specific flowers in the vase. Eventually he could take it no longer: 'It's called "Fuckthatforalarkia"!' he exclaimed.

When Jill McEwen sat for her watercolour portrait in 1997 she was astonished by the speed at which he painted and also the way he used only one brush – a large sable hair which gathered to a fine point when wet – for a work that required both facial detail and the broad sweep of a bottle-green Ossie Clark overcoat. In general he never uses pencil with watercolour but there are exceptions. In *Sick Child*, of Nicholas in bed with a cold, there is a touch of pencilwork – a few lines on the lowest pillow and some vigorous scribbling for the hair. It irritates him when people draw distinctions between his oils and watercolours and indeed he uses both mediums in a remarkably similar fashion. In *Kite Standing in a Room, Peking* (1980), he treats the raw canvas the same as if it were bare paper, the body of the kite left unpainted except for touches of white at the wing tips.

He was sixty on 12 March 1996, a year which provided two major revelations: Egypt again and his first visit to Antwerp, Ghent and Brussels to see the Flemish masters.

'At Luxor in the Valley of the Queens there were these "new" – only 1650 BC; but in Egypt you call that new! – tomb paintings of Nefertiti. It cost 100 Egyptian pounds to go in and they only allow 25 visitors a day for 15 minutes because the walls are foetid. It's only safe to go in for a few minutes and you try not to breathe. It's the most wonderful thing to see. These wonderful frescoes in the most brilliant colours that are original. They haven't altered since.'

Another highlight was a flight in a hot air balloon over Luxor. The upshot is the blue painting *Luxor* (1996), a detail from which is reproduced as the jacket for this book. It is his largest work to be inspired by Arabic mathematics. Based on the number 13, the suit of cards, and multiplied by four to add up to a pack; it measures 13 units across and 52 down, and is divided into four scenes: The Nile (illustrated on the jacket), the Valley of the Queens, the mountains, and finally at the top 'and THE most exciting – I wanted to die! – is the hot air balloon in which Nicky and I sailed along'.

This painting relates to another recent work *Garrick Bridge* (1996), an identifiable group of his bridge-playing cronies and fellow members of the Garrick Club. Bridge players will observe the grand slam on the left-hand table, with seven tricks won and six cards left to play. On the other table one hand holds five cards, while the dummy shows eight. The nine of diamonds, or 'curse of Scotland', is a real card glued to the surface. The diamonds of the background pattern add up to unlucky 13, vertically and horizontally: 'It's entire frivolity – combined with death'. London clubs are like antechambers to eternity. Older members hope to drop down dead in them, and some succeed. A typical Procktor touch is the 'Smoking is Permitted' sign, in place of the Garrick's 'Smoking not Allowed'. The painting relates to *Skull* (1976), another image of death in stark contrast to its surroundings; and even to *Body and Soul*.

Self-Portrait 1996

It seems strange that Procktor had never been to see the Belgian museums before, since his favourite book of art criticism is Eugène Fromentin's *The Masters of Past Time, Dutch and Flemish painting from Van Eyck to Rembrandt*. But in the summer of 1996 he finally made good the oversight, doing a tour of Antwerp, Brussels, Bruges and Antwerp. 'As Fromentin puts it: "Van Eyck is at Ghent, Memling at Bruges, Rubens at Antwerp". That's the way to write, darling. No frills, no nonsense,' he says. He travelled with David Gwinnutt. 'Antwerp is the greatest museum I've ever seen. The Rubenses are of a grandeur you just don't see today. *The Raising of the Cross*, the *Descent from the Cross* and so on, each one 60ft high! I've never seen painting like it. In the *Descent* the painting is quite loose – just two brushstrokes to indicate the tone of a leg. And there is Van Eyck's *Holy Lamb* in Ghent, this great, great triptych masterpiece. Even Degas said after visiting Antwerp and Ghent: "The rest of us who paint are dogs". I prefer Flemish painting to Italian. Who would get my ultimate vote? Memling or Dirk Bouts.'

Election to the Royal Academy followed in the summer. It had been a problematic year in various private ways. The public mark of recognition by his peers pleased him.

This book celebrates Procktor's sixtieth birthday. Reg Butler told him at the Slade that there were 70,000 art students, but by the time they were 30 the number of them who remained artists had shrunk to a few hundred and by the time they were 60 to a mere handful. Procktor has won his place in that select band; so what direction will his painting next take? At the end of his autobiography he wrote: 'My painting now is much more like the paintings of my youth. The approach to the easel, brandishing a trowel and palette knife, is much closer to the paintings of my youth, that is to say in allowing impulses free reign and not rendering them into conventional coherence. I don't want to rely on convention.'

He never has.

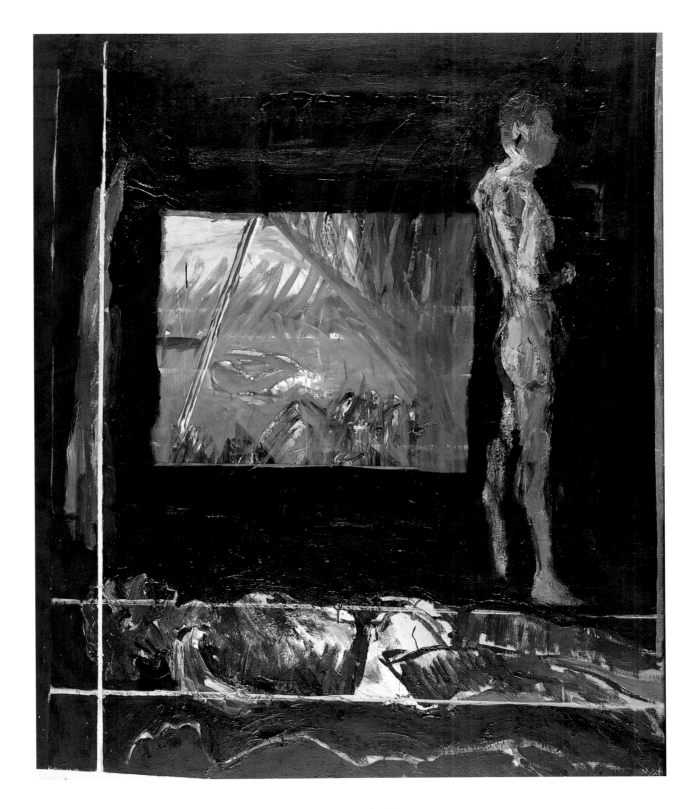

Figures by a Pool 1963

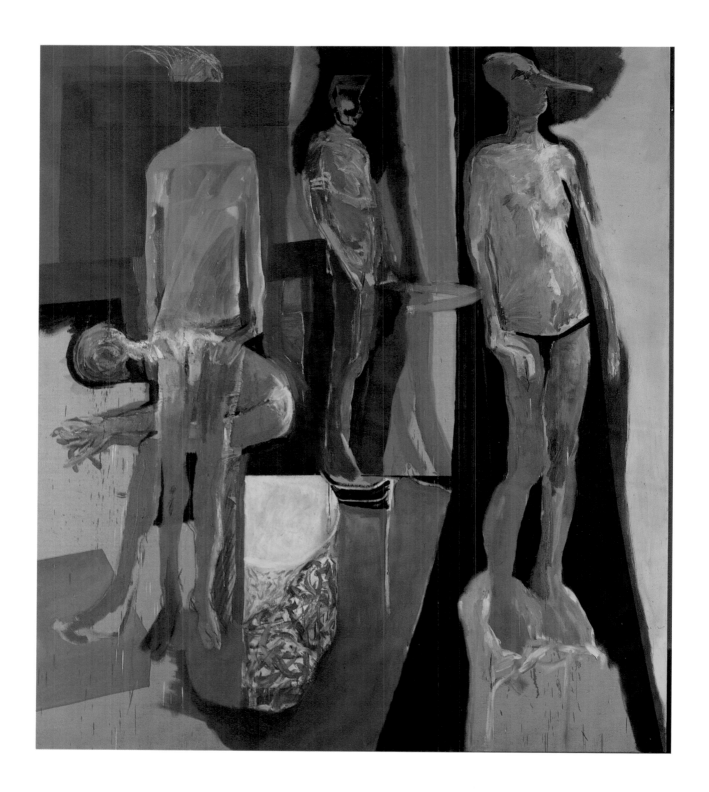

Parade 1963-1964

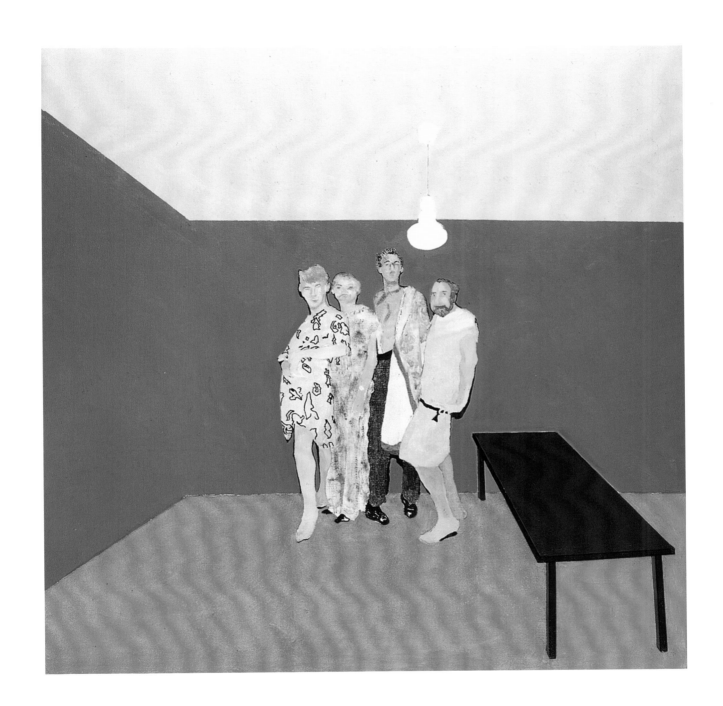

Hallowe'en 1966

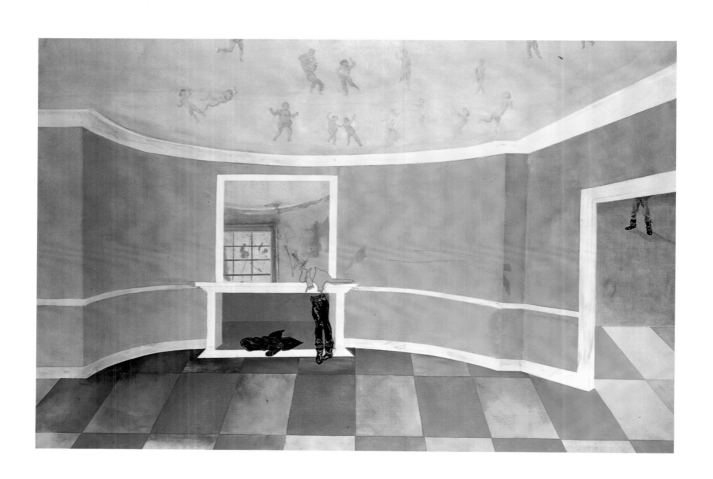

6 AM at Heaton Hall 1966

Mick Jagger 1966

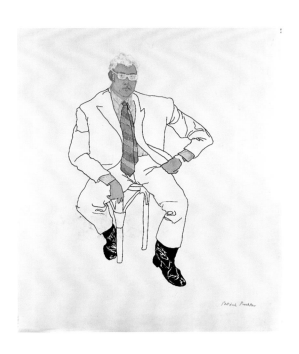

M. Jacques Demase 1967

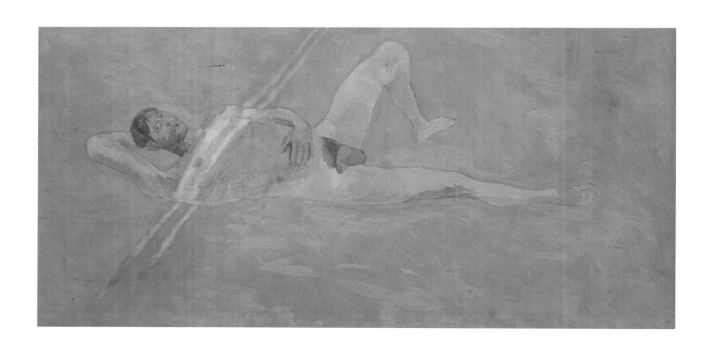

Reclining 1966 - 1972

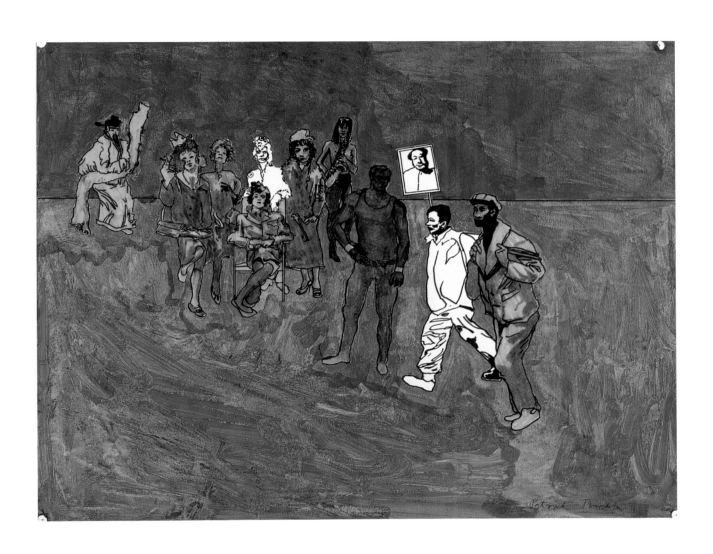

Expo '67 Montreal Mural Design 1967

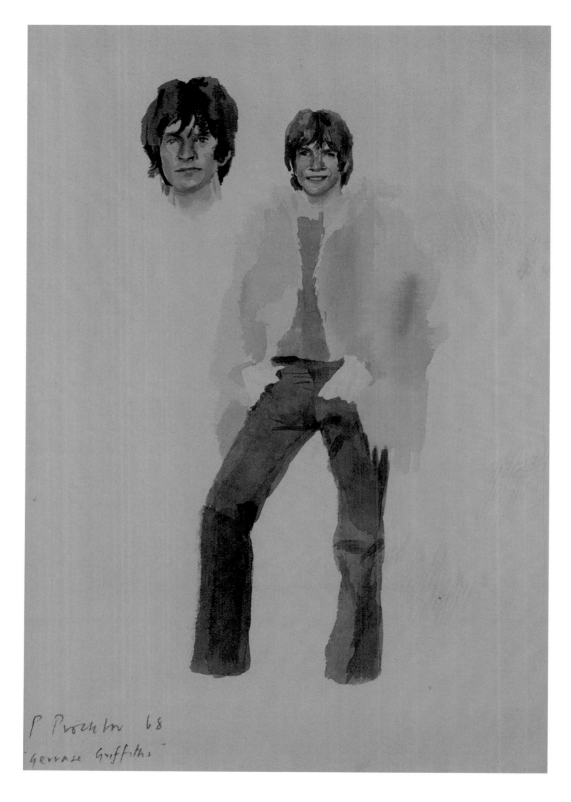

Gervase 1968

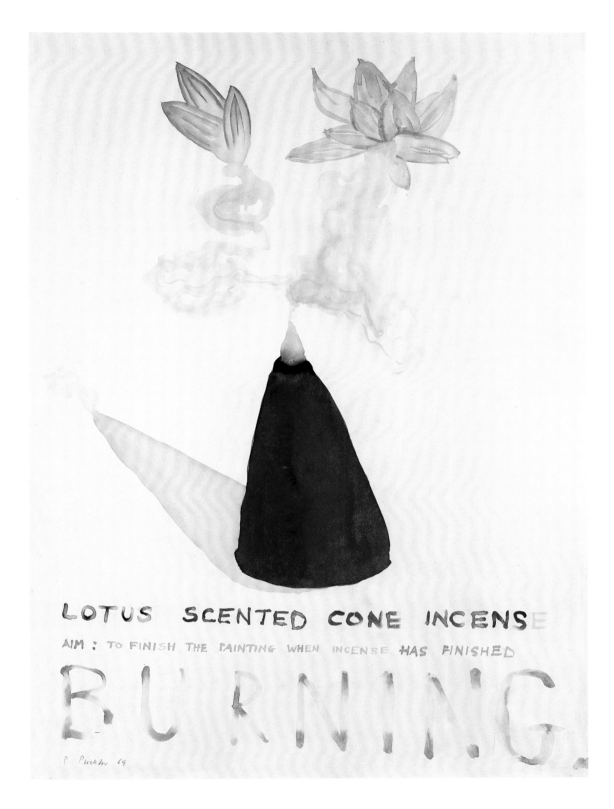

Lotus Scented Cone Incense 1969

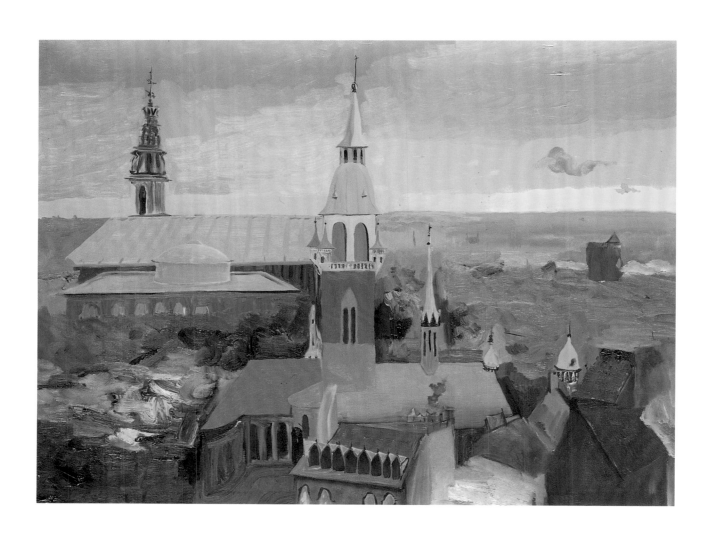

Copenhagen, Panorama 1972

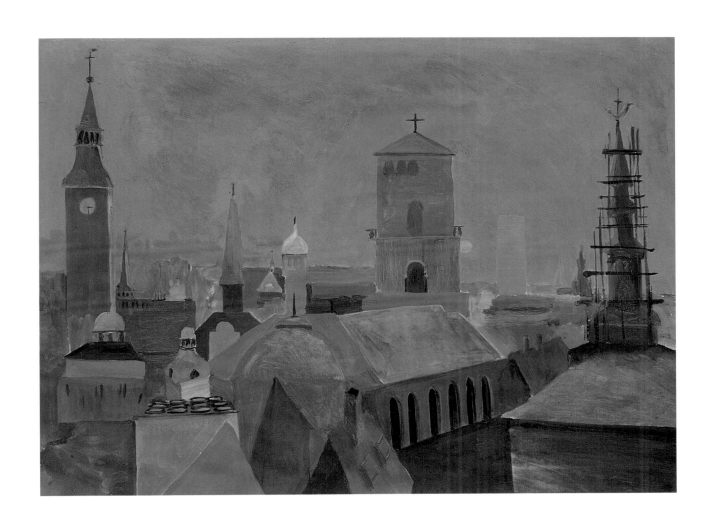

Copenhagen, Panorama 1972

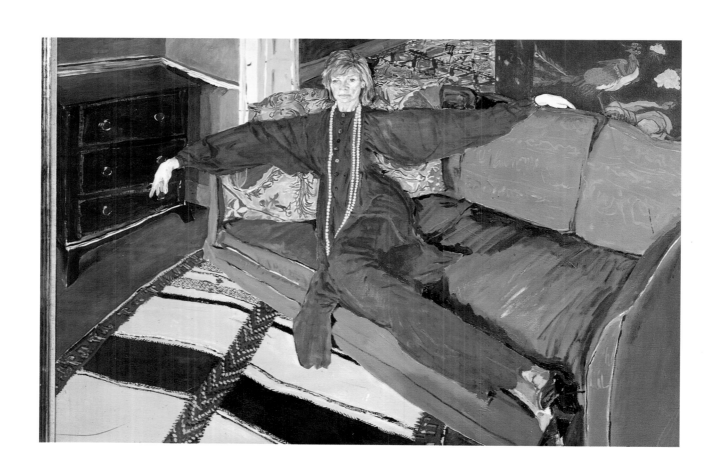

Miss Jill Bennett 1972

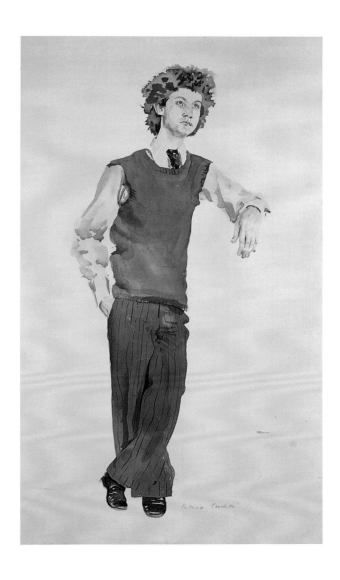

Anthony Palliser 1974

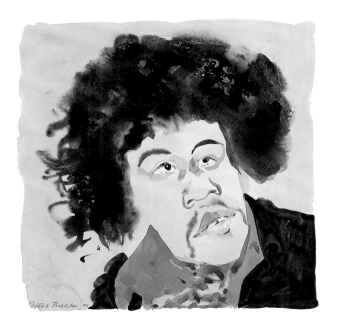

Jimi Hendrix 1973

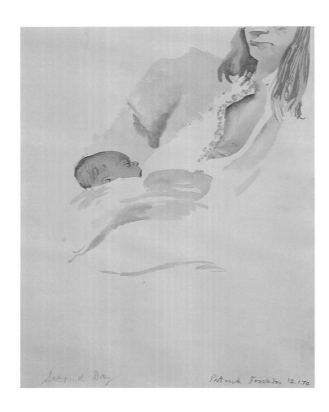

Nicholas: Second Day 1974

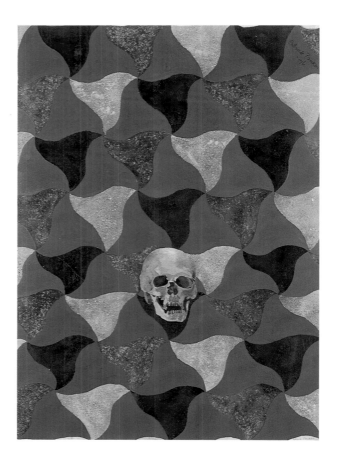

Skull 1976

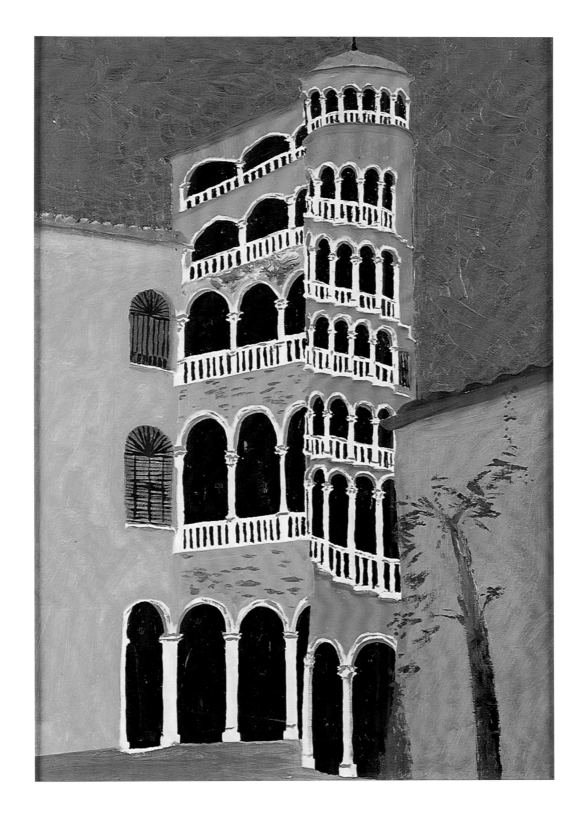

Scalorini del Bovolo, Venice 1977

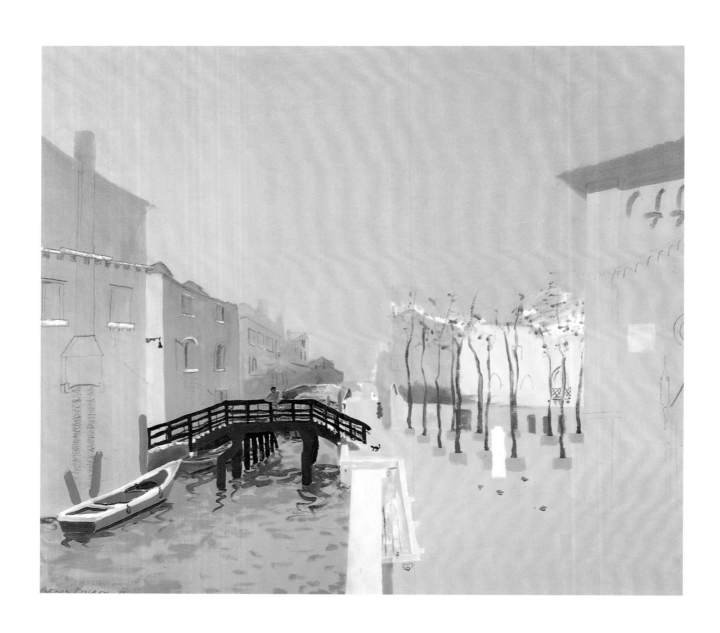

Campo S. Alvise, Venice 1978

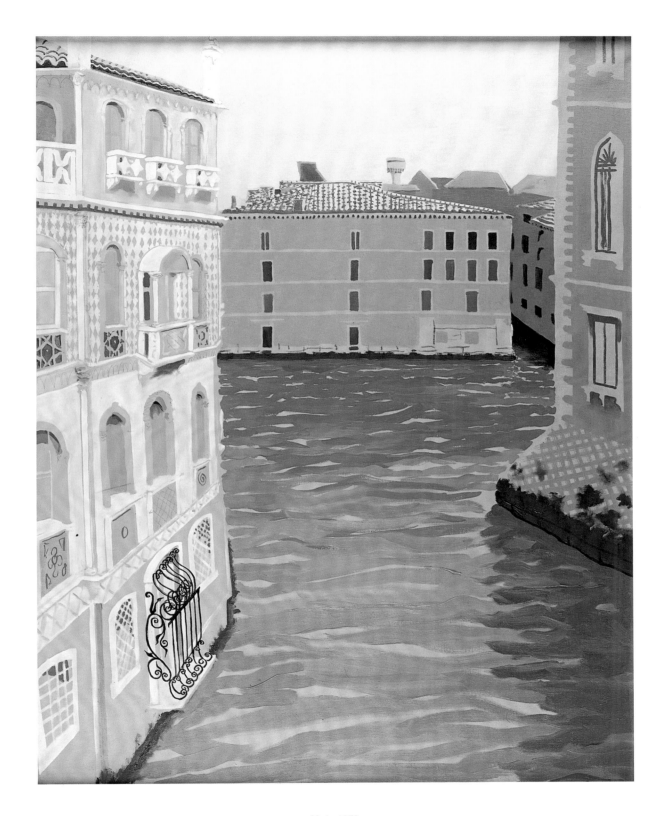

Venice 1978

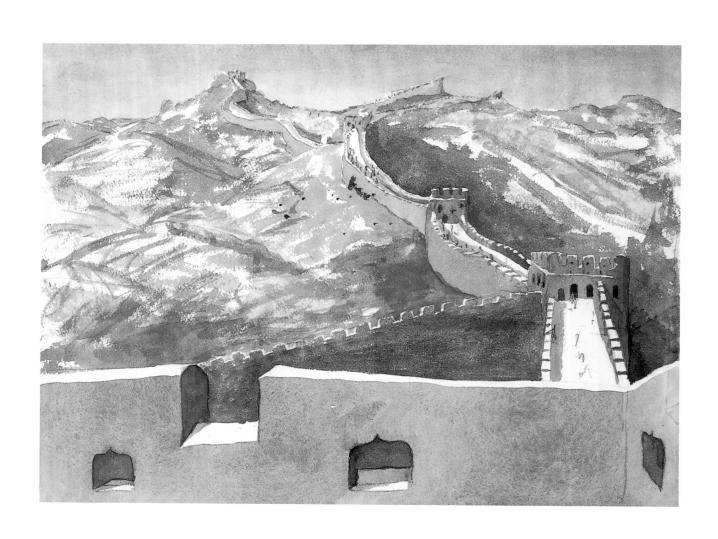

The Great Wall, Peking (Pa Ta Ling) 1980

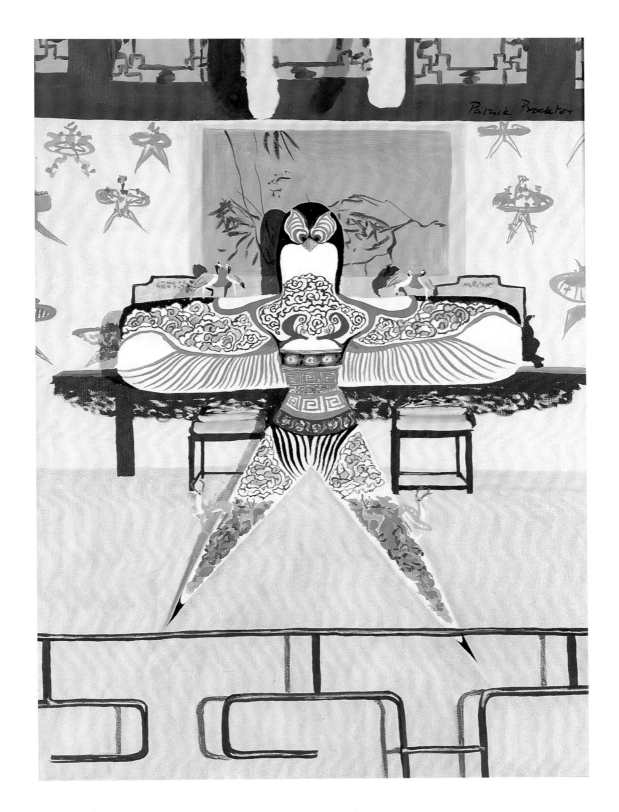

Kite Standing in a Room, Peking 1980

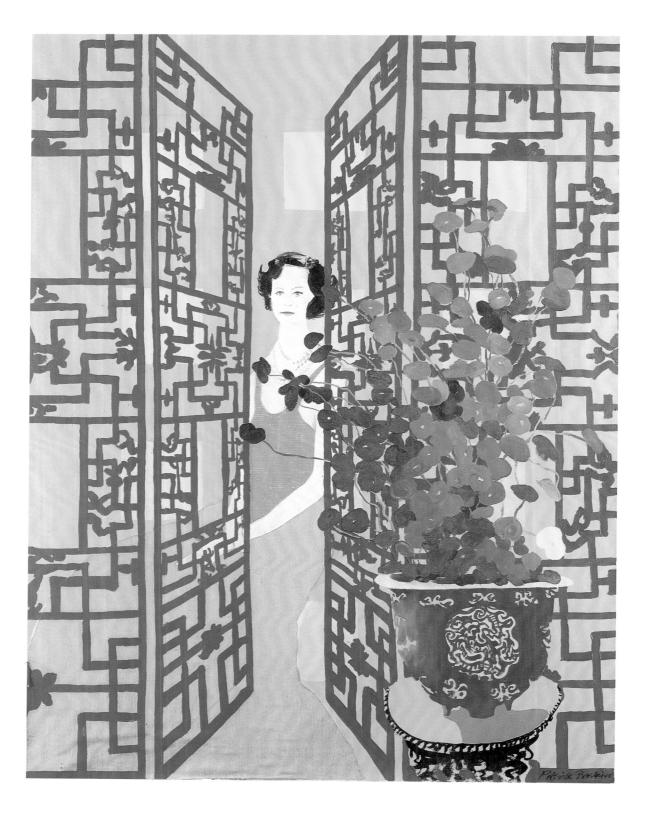

Princess Margaret Coming of Age 1981 (after Cecil Beaton)

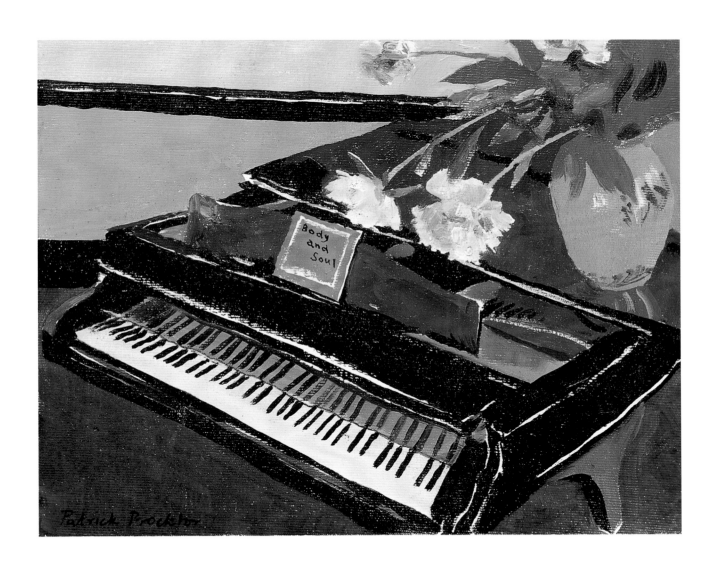

Body and Soul 1981

Juliet 1982

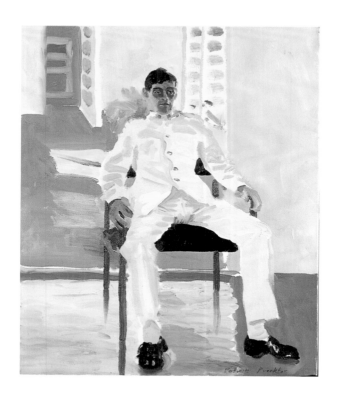

Corporal R J Ransome, 1 Royal Anglian 1983

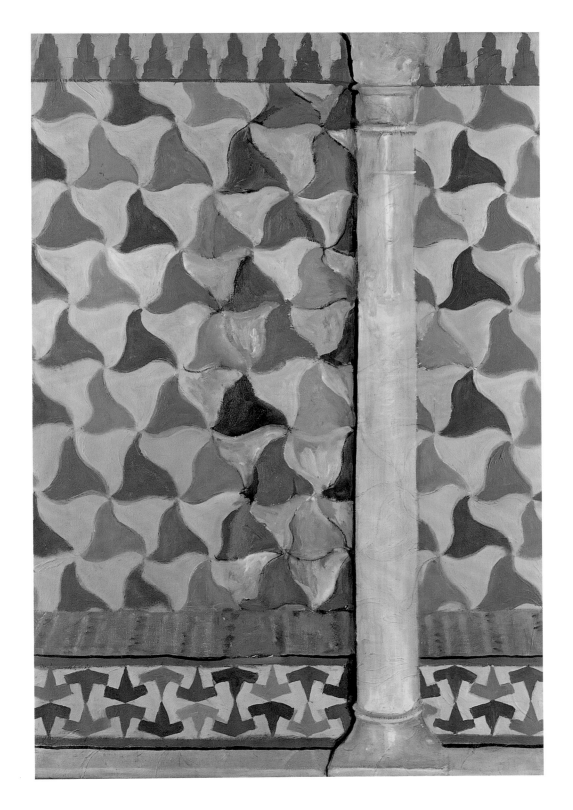

A Ghost in the Alhambra 1982-1987

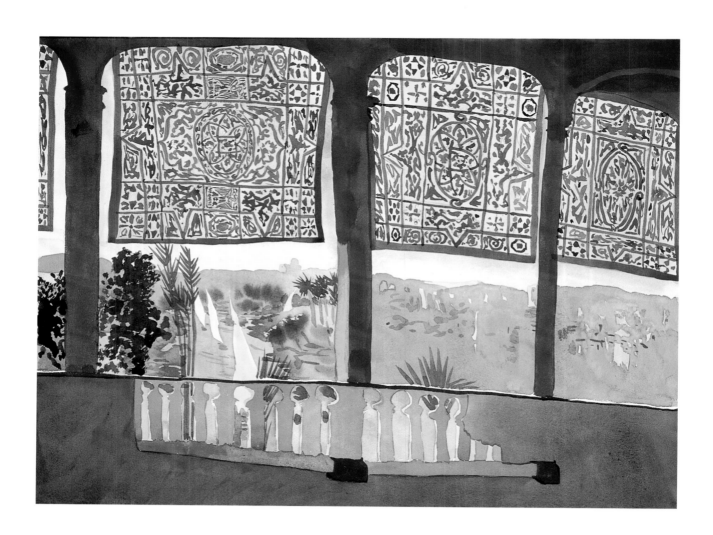

Cataract Terrace, Aswan 1984

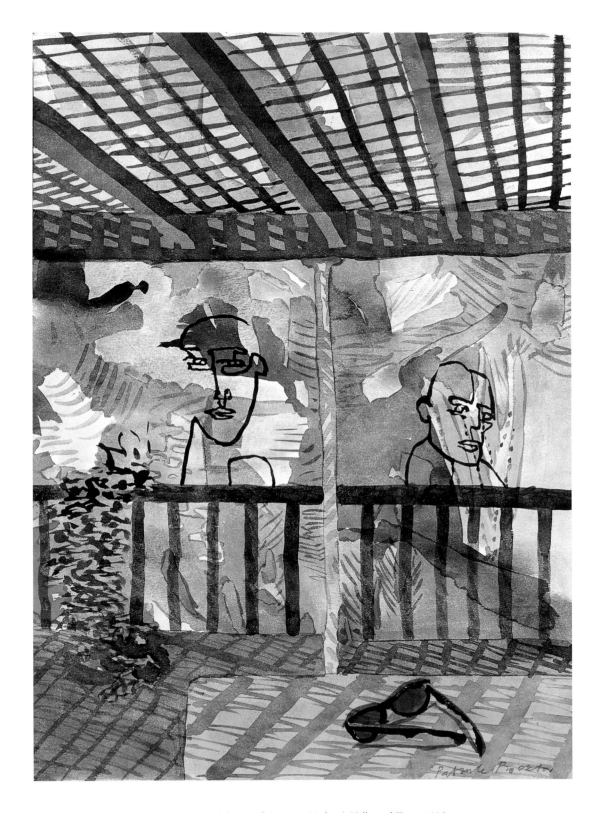

Two Wire Heads by David Graves on Hockney's Hollywood Terrace 1984

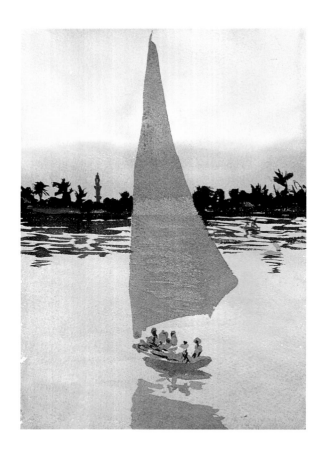

Nile Felucca 1984

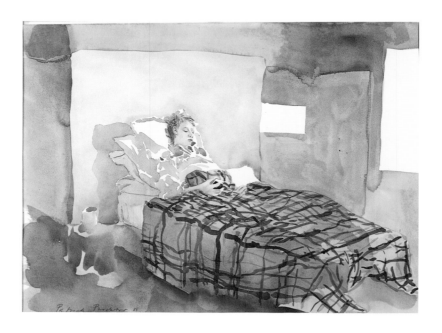

Sick Child 1984

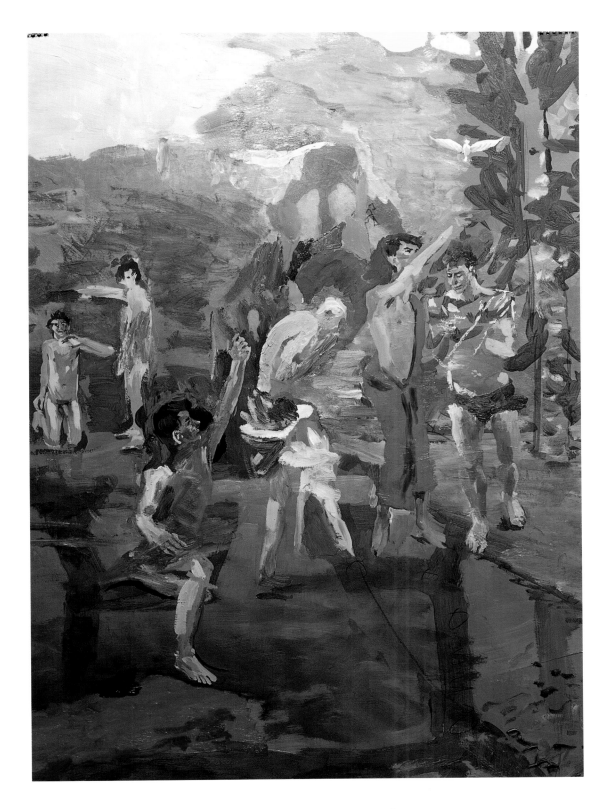

St. John Baptising the People 1984 (Detail)

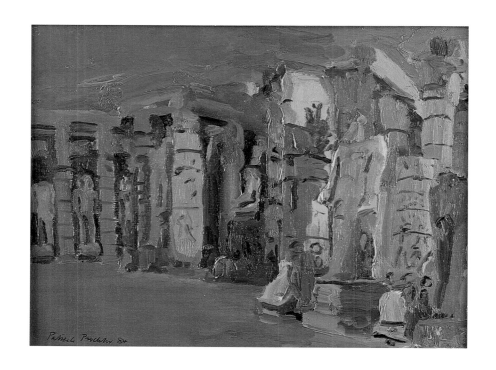

Temple of Luxor 1984

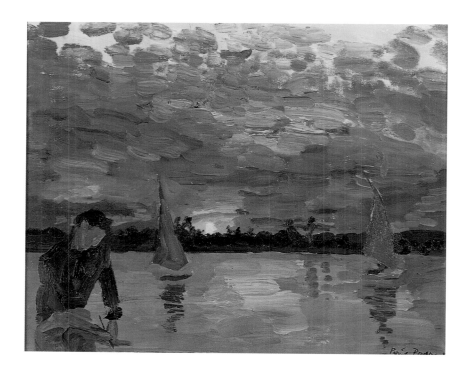

Peter in Luxor 1984

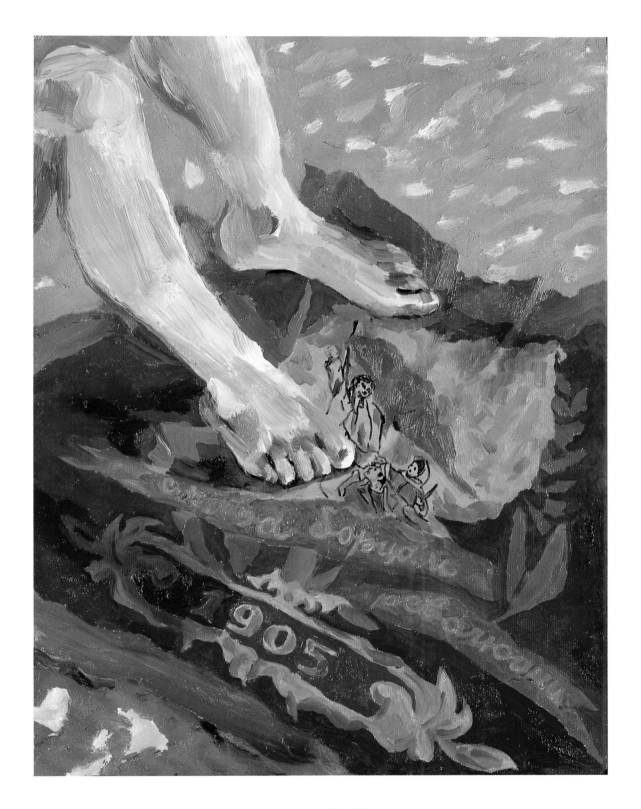

'Revolution 1905' 1986

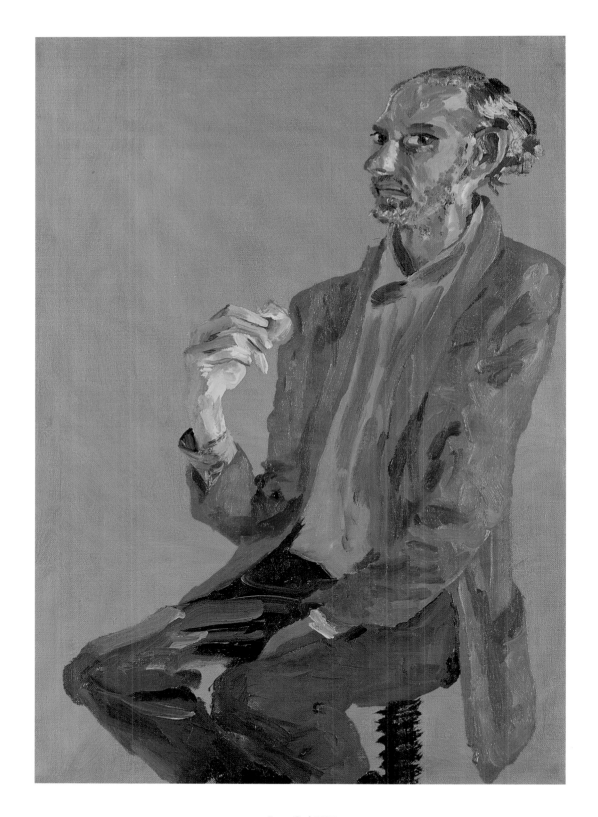

Roger Cook 1987

The Seagull 1987

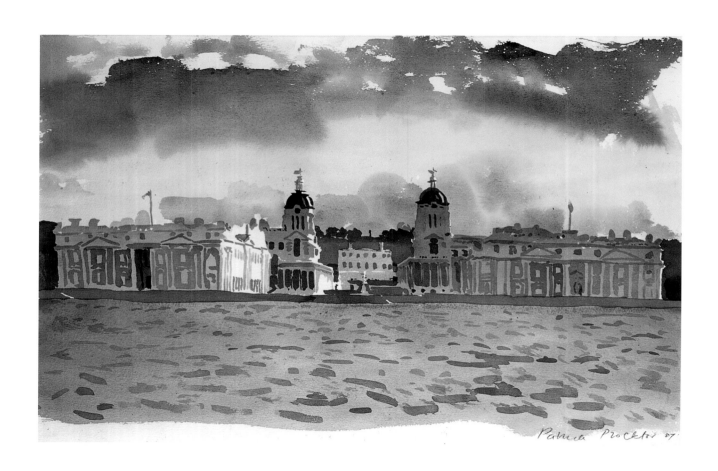

Greenwich 1987

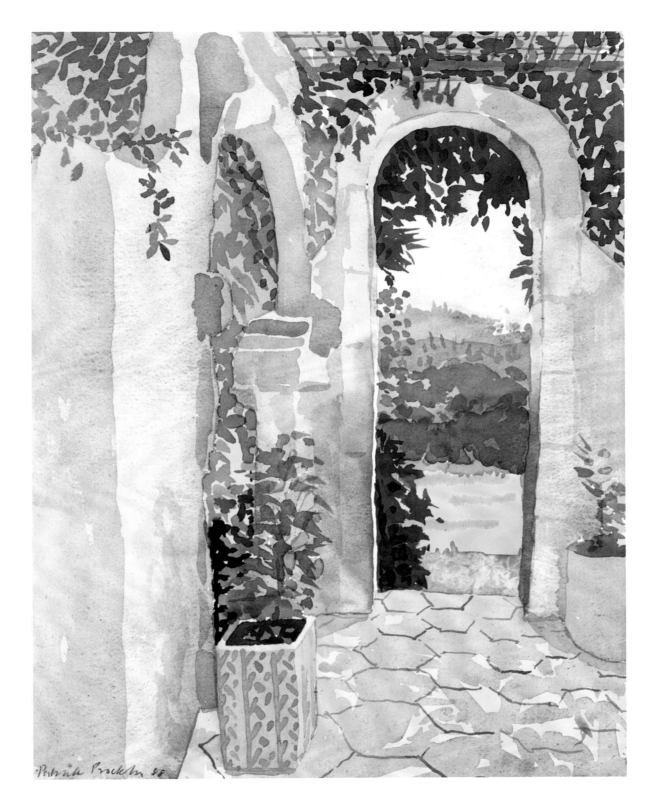

Corfu, Kombitsi 1988

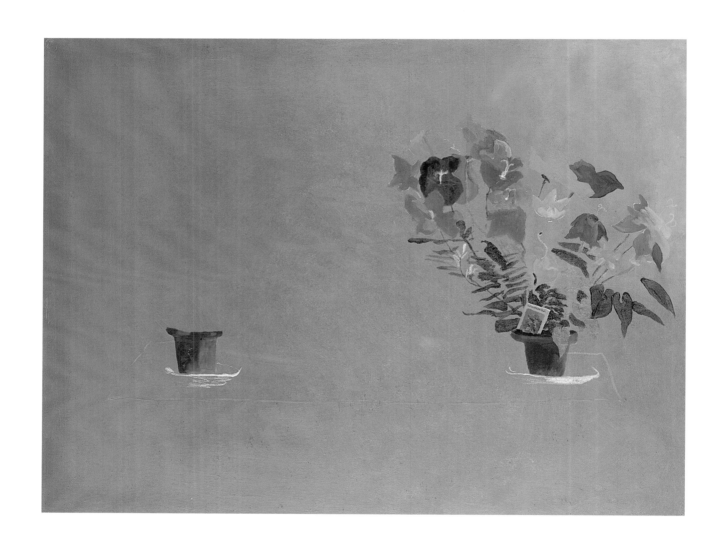

Campanula 1988

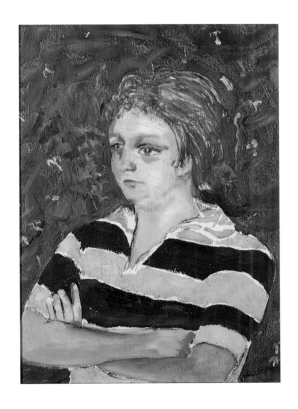

Nicholas 1988

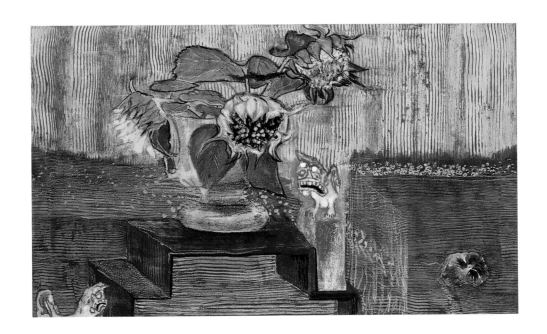

Soleils 1989

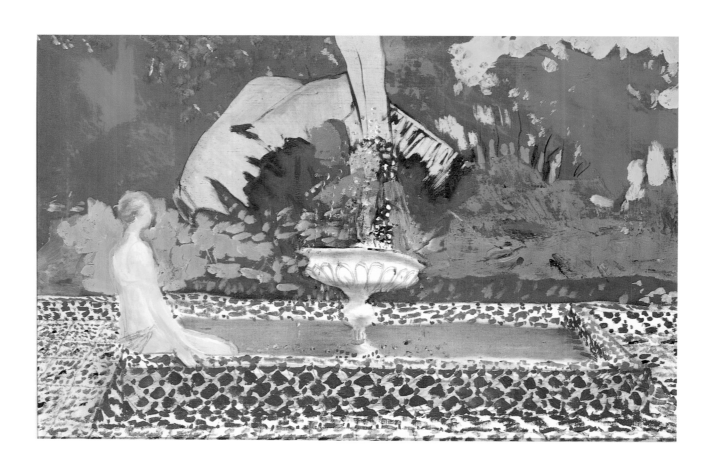

Figure by a Pool 1989

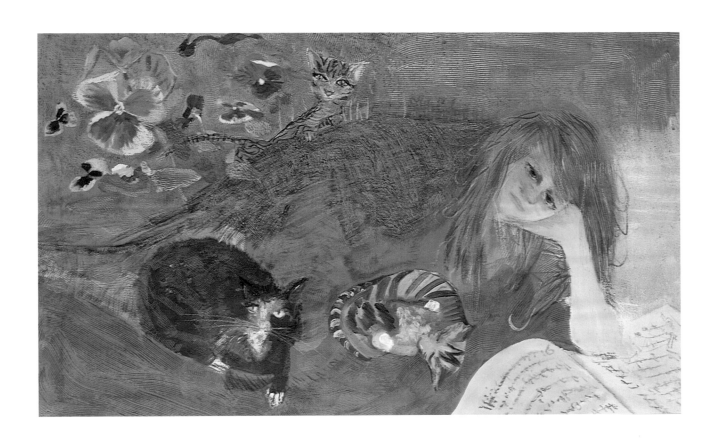

Juliet 1989

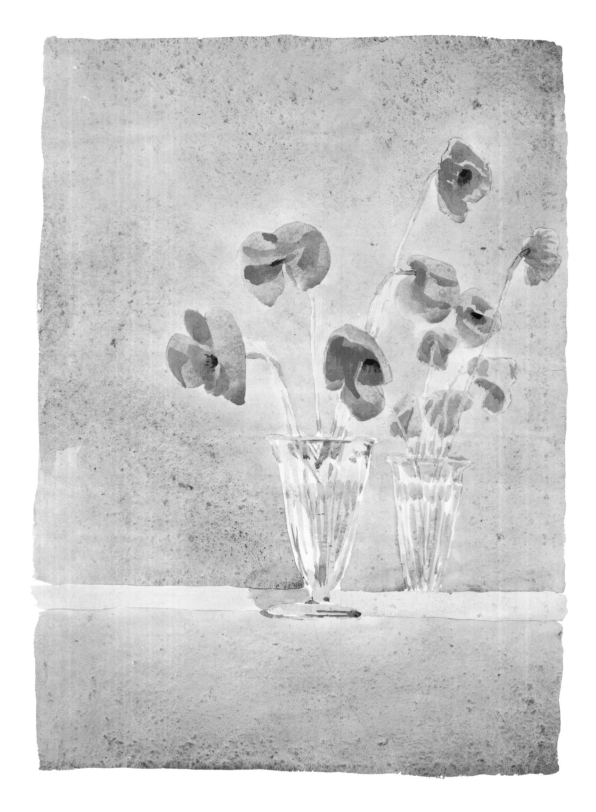

Poppy 1991

Rose 1991

Kyoto Blossom and Flamingoes 1991

Coq et Poule, L'Abbatiale, France 1991

Peach and Apricot 1991

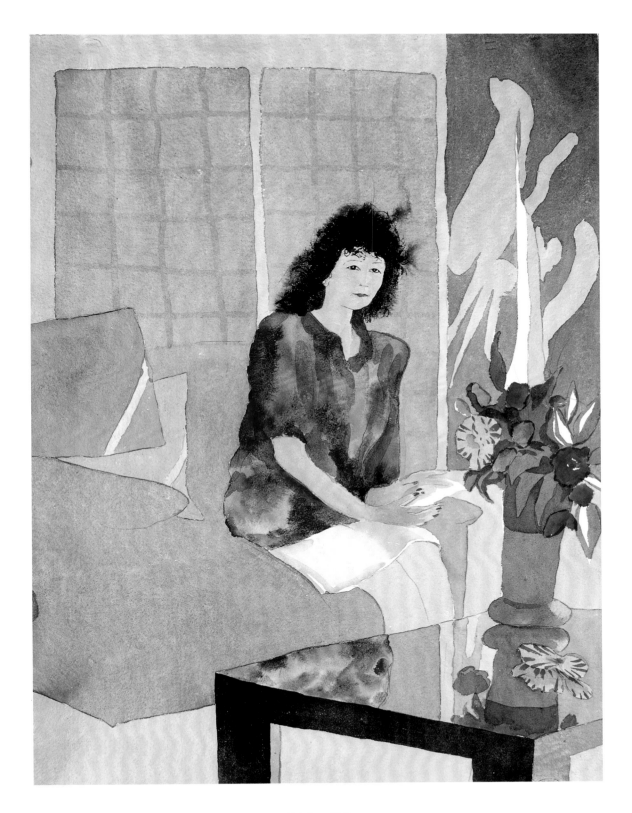

Emi Asano 1991

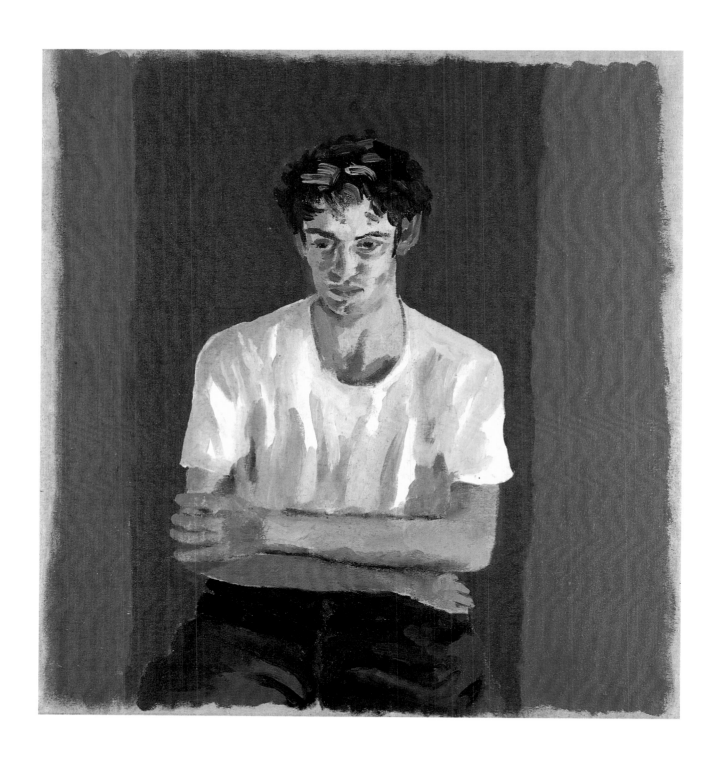

Portrait of a Young Man 1991

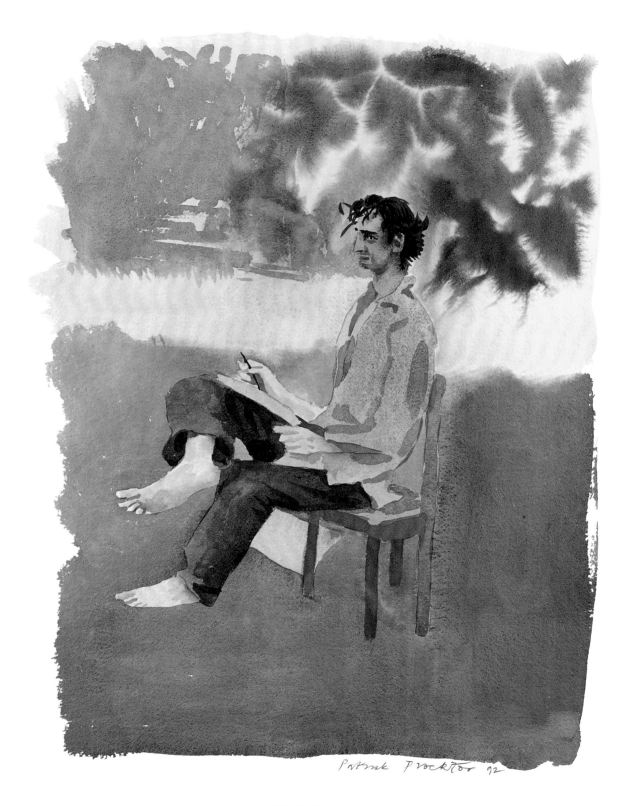

Richard Selby, L'Abbatiale, France 1991

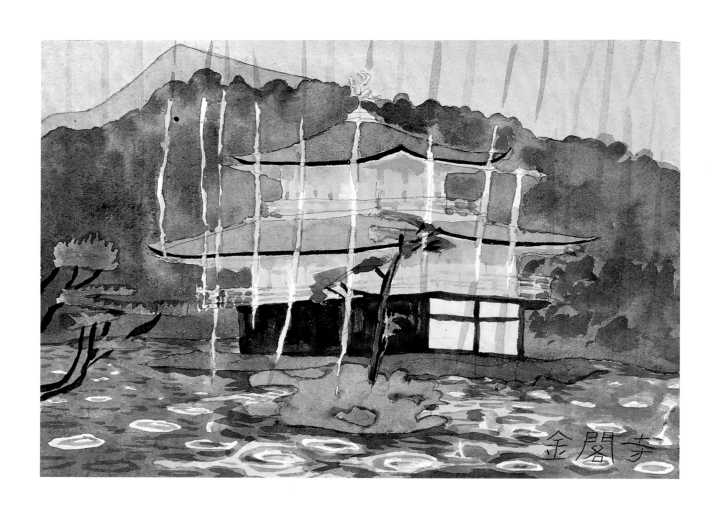

Kyoto, Golden Temple, Rain 1991

Rice Jars 1991

Anthurium, MV Ocean Pearl 1993

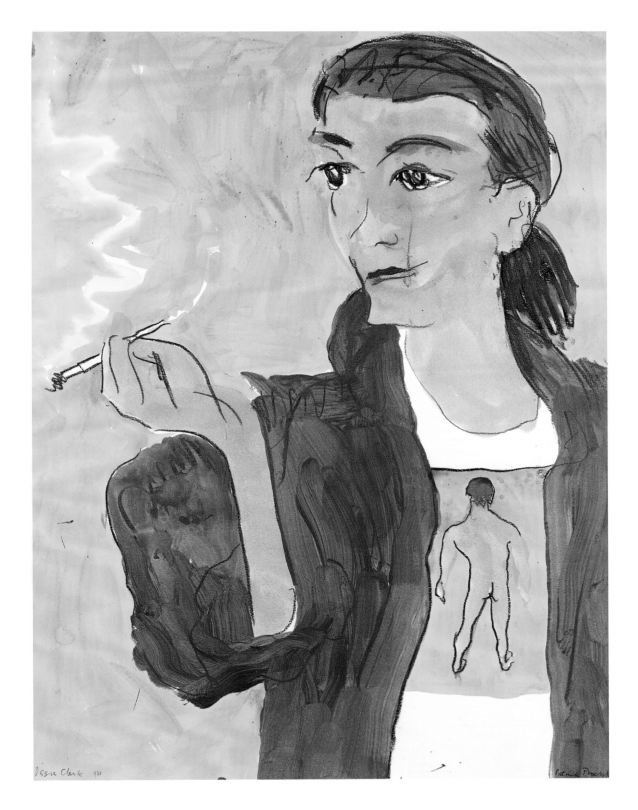

Ossie Clark 1994

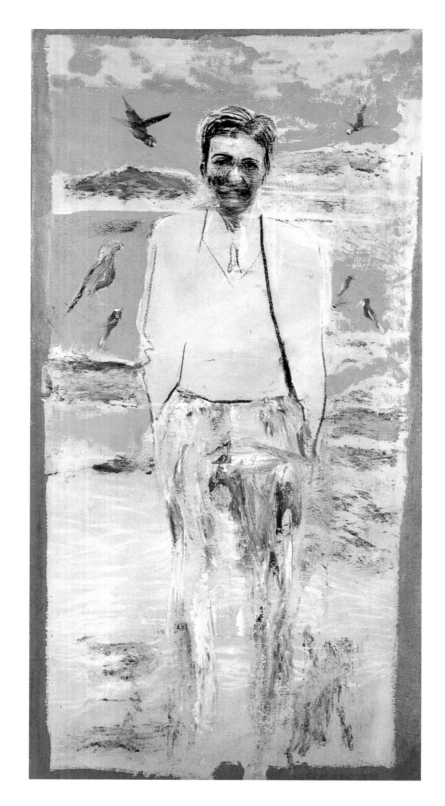

L'Heure Bleue 1994

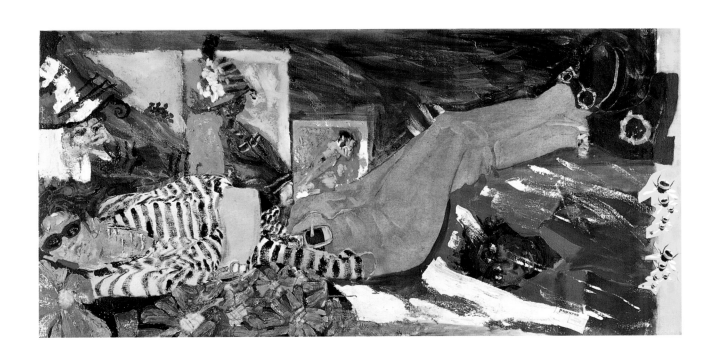

Ma Griffe 1994

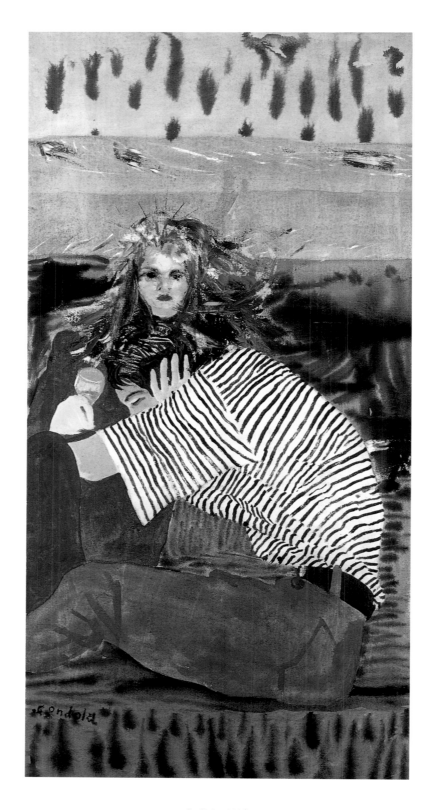

Le Baiser 1994

Try 1996

Gooseberry 1996

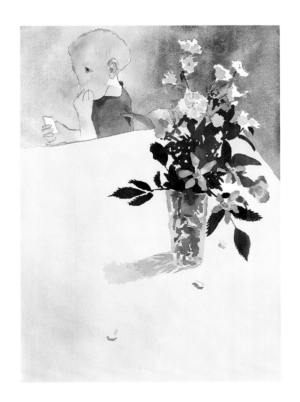

Patch 1997

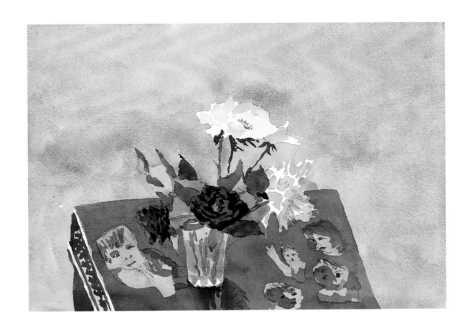

Emily 1997

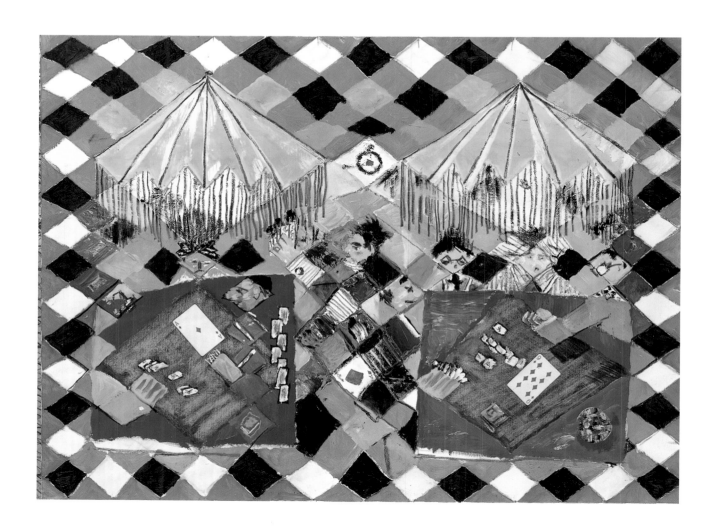

Garrick Bridge 1996

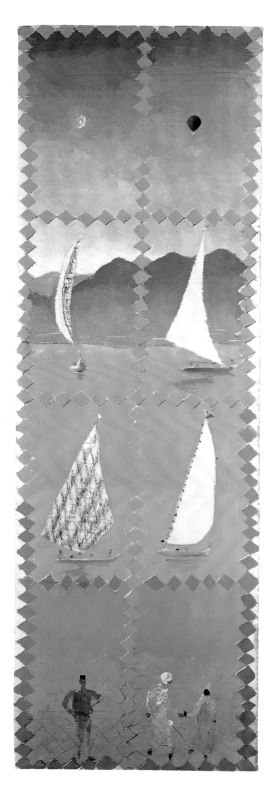

Luxor 1996

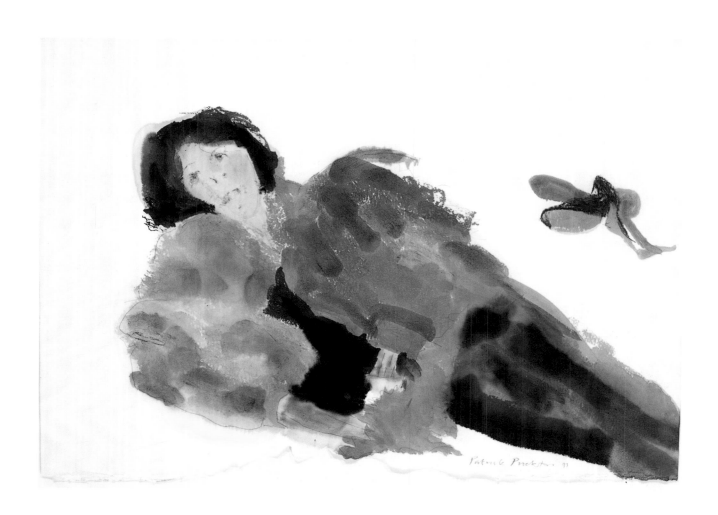

Jill 1997

BLACK AND WHITE ILLUSTRATIONS

54 *Corporal R J Ransome, 1 Royal Anglian* 1983
Oil on canvas 36 x 24 in (91.5 x 61 cm) (Collection Imperial War Museum, London)

55 *A Ghost in the Alhambra* 1982-1987
Oil on canvas 41¾ x 28 in (106 x 71.1 cm) (Collection The Artist)

56 *Cataract Terrace, Aswan* 1984
Watercolour 18 x 24 in (45.7 x 61 cm) (Private Collection)

57 *Two Wire Heads by David Graves on Hockney's Hollywood Terrace* 1984
Watercolour 20 x 14 in (51 x 36 cm) (Collection The Artist)

58 *Nile Felucca* 1984
Watercolour 10 x 7 in (25.5 x 17.5 cm) (Private Collection)

58 *Sick Child* 1984
Watercolour 17¾ x 23¾ in (45 x 60.5 cm) (Collection The Artist)

59 *St John Baptising the People* 1984 (Detail)
Oil on panel 48 x 96 in (122 x 244 cm) (By kind permission of the Dean and Chapter of Chichester)

60 *Temple of Luxor* 1984
Oil on canvas 18 x 24 in (45.7 x 61 cm) (Collection The Artist)

60 *Peter in Luxor* 1984
Oil on canvas (in hand-painted frame) 16 x 30 in (40.5 x 76.3 cm) (Collection The Artist)

61 *'Revolution 1905'* 1986
Oil on canvas 18 x 12 in (46 x 30.5 cm) (Private Collection)

62 *Roger Cook* 1987
Oil on canvas 23¾ x 18 in (60 x 45.7 cm) (Collection Elton John)

63 *The Seagull* 1987
Oil on canvas 30 x 40 in (76.2 x 101.6 cm) (Private Collection)

64 *Greenwich* 1987
Watercolour 15½ x 11⅜ in (39. 5 x 29 cm) (Private Collection)

65 *Corfu, Kombitsi* 1988
Watercolour 15¾ x 11⅝ in (39.7 x 29.5 cm) (Private Collection)

66 *Campanula* 1988
Oil on canvas 28 x 36 in (71 x 91.2 cm) (Collection Lord and Lady Tanlaw)

67 *Nicholas* 1988
Oil on canvas 22 x 16 in (55.9 x 40.6 cm) (Collection The Artist)

67 *Soleils* 1989
Oil and pastel on canvas 30 x 48 in (76.2 x 121.9 cm) (Private Collection)

68 *Figure by a Pool* 1989
Oil on canvas 19¾ x 30 in (50.5 x 76 cm) (Private Collection)

69 *Juliet* 1989
Oil and pastel on canvas 30 x 47¾ in (76.2 x 121.9 cm) (Collection Galerie Enatsu, Japan)

70 *Poppy* 1991
Watercolour 22 x 14¼ in (55 x 37 cm) (Collection Mischcon de Reya)

71 *Rose* 1991
Watercolour 22 x 14½ in (55 x 37 cm) (Collection The Redfern Gallery)

72 *Kyoto Blossom and Flamingoes* 1991
Watercolour 13¾ x 10 in (34.9 x 25.5 cm) (Collection Galerie Enatsu, Japan)

73 *Coq et Poule, L'Abbatiale, France* 1991
Watercolour 21½ x 14 in (54.5 x 36 cm) (Collection Lord and Lady Tanlaw)

74 *Peach and Apricot* 1991
Oil on canvas 32 x 22 in (81.5 x 56 cm) (Collection The Artist)

75 *Emi Asano* 1991
Watercolour 25 x 18¾ in (63.5 x 47 cm) (Collection The Redfern Gallery)

76 *Portrait of a Young Man* 1991
Oil on canvas 32 x 30 in (81.5 x 76.5 cm) (Collection Le Cadre Gallery, Hong Kong)

77 *Richard Selby, L'Abbatiale, France* 1991
Watercolour 24¾ x 18½ in (63 x 47 cm) (Collection The Artist)

78 *Kyoto, Golden Temple, Rain* 1991
Watercolour 10 x 14 in (25.5 x 35.5 cm) (Collection Galerie Enatsu, Japan)

79 *Rice Jars* 1991
Watercolour 21¾ x 14½ in (55 x 37 cm) (Private Collection)

80 *Anthurium, MV Ocean Pearl* 1993
Watercolour 12 x 16 in (30.6 x 41 cm) (Collection The Artist)

81 *Ossie Clark* 1994
Acrylic and charcoal 24¼ x 18 in (62 x 46 cm) (Collection The Artist)

82 *L'Heure Bleue* 1994
Oil on canvas 63 x 31½ in (160 x 80 cm) (Private Collection)

83 *Ma Griffe* 1994
Oil on canvas 31½ x 63 in (80 x 160 cm) (Collection Alex Tong)

84 *Le Baiser* 1994
Oil on canvas 63 x 31½ in (160 x 80 cm) (Collection Galerie Biedermann, Munich)

85 *Try* 1996
Oil on canvas 39 x 37½ in (99 x 95 cm) (Collection The Artist)

86 *Gooseberry* 1996
Watercolour 23 x 16¼ in (58 x 41.5 cm) (Collection The Artist)

87 *Patch* 1997
Watercolour 20 x 14 in (51 x 36 cm) (Collection The Artist)

87 *Emily* 1997
Watercolour 14 x 20 in (36 x 51 cm) (Collection The Artist)

88 *Garrick Bridge* 1996
Oil on canvas 36 x 48 in (91.5 x 122 cm) (Collection The Artist)

89 *Luxor* 1996
Oil on canvas 96 x 36 in (244 x 91 cm) (Collection The Artist)

90 *Jill* 1997
Watercolour in 10½ x 16 in (41 x 63cm) (Private Collection)

BIOGRAPHICAL NOTES

1936 Born Dublin. Younger of two brothers. Father dies 1940. Brought up by mother and maternal grandparents in London and Brighton. His grandmother was a talented amateur painter of still life.

1946 Highgate School. The art master was the Welsh landscapist and RA, Kyffin Williams.

1952-54 Employed in large North London firm of builders' merchants.

1954-56 Conscripted into Royal Navy as a student of Russian language. Subsequently visited Russia three times, as an interpreter with various delegations.

1958 Entered the Slade; under the influence of William Coldstream, Keith Vaughan, William Townsend, Claude Rogers and Robert Medley, among others. His painting developed in the dark figurative tradition which then held sway.

1962 Graduated from the Slade and, with the help of Rome and Abbey, travelled to Italy and Greece in the company of the artist Michael Upton. In the winter of 1962, he painted a number of large figures in a landscape which formed his first exhibition at The Redfern Gallery in 1963. All the paintings were sold before the opening.

1963 Moved to what had been William Coldstream's flat in St Marylebone, where he still lives.

1964 Exhibited in the first 'New Generation' show at the Whitechapel Gallery, selected by Bryan Robertson.

1965 Second one-man show at The Redfern Gallery consisted of portraits and landscapes still far from realistic. The critics pointed to a supposed surreal influence from his contemporary and friend R B Kitaj.
First travel in USA in company with David Hockney, Norman Stevens and Colin Self.

1967 A new exhibition at The Redfern Gallery gained notoriety because of enormous canvases of Chinese Red Guards and American leather boys.

1968 First exhibited watercolours, chiefly portraits. First exhibition in New York, the subject of which was entirely portraits of his friend Gervase Griffiths. Critical reaction nil.

1969 Exhibited large watercolours at The Redfern Gallery based on memories of New York and Morocco.

1970 1st Jan. Set off by train, boat and 'plane for India and Nepal. Landscapes of India in oil and watercolour exhibited at The Redfern Gallery that winter.

1972 First exhibition at the Galleria del Cavallino, Venice. New exhibition at The Redfern Gallery of landscapes of Venice and portraits.

1973 Married to Kirsten at the Danish Church, St Katherine's in Regent's Park.

1974 Birth of son Nicholas.
Travelled to South Africa by sea; later in 1974, an exhibition at The Redfern Gallery of portraits of Negroes and landscapes of home and abroad.

1976 Exhibition at Galerie Biedermann, Munich. Exhibition at the Redfern Gallery including a suite of aquatints and etchings for *The Rime of the Ancient Mariner* by Samuel Taylor Coleridge; published also as a book in 1978 by Editions Alecto and The Redfern Gallery; printed by the Rampant Lions Press, Cambridge.

Cherry aquatint 1997

1977/78 Further exhibitions in England and abroad. Exhibition at The Redfern Gallery of Venice landscapes and publication of the Venice Suite of seven aquatints.

1980 Visited China. Subsequent exhibition at The Redfern Gallery attended on separate occasions both by HRH The Princess Margaret and HE The Chinese Ambassador who made a speech.

1983 Painted and made designs and models at the Royal Opera House for the new production of 'Turandot', later abandoned by the management.

Visited Belize at the invitation of the Imperial War Museum to paint soldiers.

1984 Death of Kirsten.
Painted Reredos for St John the Baptist's Chapel in Chichester Cathedral, consecrated on 7th October.
Travels in Egypt

1985 Visited Portugal at the invitation of the British Council to cover HM The Queen's visit in watercolour.
Retrospective exhibition of graphic work since 1959 at the Birmingham Museum and Art Gallery.
Landscapes of Egypt exhibited at The Redfern Gallery.

1986 Exhibition at Galleria del Cavallino, Venice. Exhibition at Henley Festival and the Harris Museum in Preston

1987 Exhibited at IAM Galeria, Lisbon
Exhibited at Le Cadre Gallery, Hong Kong
Exhibition of Still Life and Portraits at The Redfern Gallery
Exhibition of theatrical designs, drawings and prints at the Marina Henderson Gallery

1988 (27th April) Television Documentary
My Britain produced by Liam White for Channel 4

1989 (18th-22nd January) One-man exhibition at The Redfern Gallery stand at the World of Drawings and Watercolours, Park Lane Hotel
Exhibited at Galerie Biedermann, Munich
Welsh Arts Council Tour of Great Britain
The Watercolour Foundation Award 1989
Exhibition of paintings and watercolours at The Redfern Gallery

1990 Exhibited at Galleria Ghelfi, Venice

1991 Exhibited at Galerie Coard, Paris
Prizewinner - The Singer & Friedlander/*Sunday Times* Watercolour Competition
Exhibition 'Le Style Japonais': Recent Oils, Watercolours and Prints at The Redfern Gallery
Autobiography: *Self-Portrait* published by Weidenfeld & Nicholson

1992 Exhibited at Tokyo Art Fair - Galerie Enatsu
Prizewinner - The Singer & Friedlander/*Sunday Times* Watercolour Competition
Visited South East Asia
Exhibited at Galerie Biedermann, Munich

1993 Exhibited Le Cadre Gallery, Hong Kong

1994 Exhibition 'Recent Paintings and Drawings and Paintings from the 1960s to 1980s' at The Redfern Gallery
Exhibited at CCA Galleries, Cambridge

1995 Exhibited at Rye Art Gallery, Rye, East Sussex

1996 Exhibition 'A 60th Birthday Tribute to Patrick Procktor' at The Redfern Gallery
Elected Royal Academician

1997 Exhibition 'Paintings, Watercolours and Drawings' at The Redfern Gallery

WORKS IN PUBLIC COLLECTIONS

Arts Council of Great Britain
Contemporary Art Society
Imperial War Museum, London
Leicestershire Education Authority
Los Angeles County Museum
National Gallery of Victoria, Melbourne
New College, Oxford
São Paulo Museum of Art, Brazil
Tate Gallery, London
The Old Jail Art Center, Albany, Texas, USA
University of Leeds
Whitworth Art Gallery, Manchester

INDEX

The artist's bedroom in Manchester Street 1991
(wall painted by friends of the artist)
Photograph by Richard Holttum

Photographic portrait of the artist in his
drawing room in Manchester Street 1991
Photograph by Richard Holttum

Manchester Street
Photograph by Richard Holttum